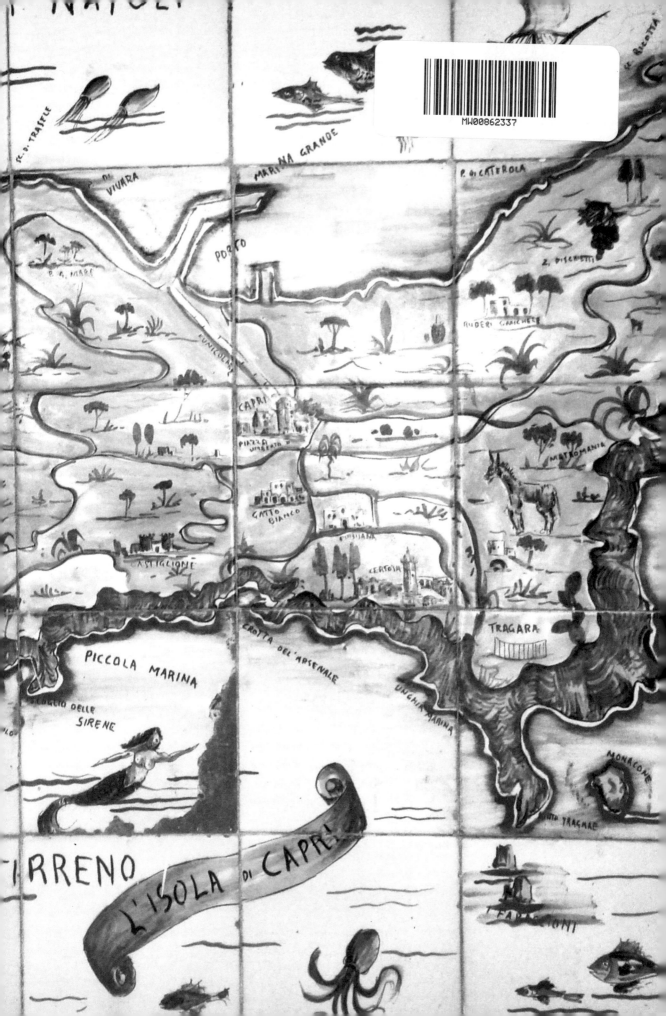

IN THE SPIRIT OF
CAPRI

Text © 2009 Pamela Fiori
© 2009 Assouline Publishing
601 West 26th Street, 18th Floor
New York, NY 10001, USA
www.assouline.com
ISBN: 978 2 75940 406 3
10 9 8 7 6 5
Color separation: Luc A.C. Retouching
Printed in the United States

PAMELA FIORI

IN THE SPIRIT OF
CAPRI

ASSOULINE

Contents

Sheer cliffs and sheer joy in Capri.

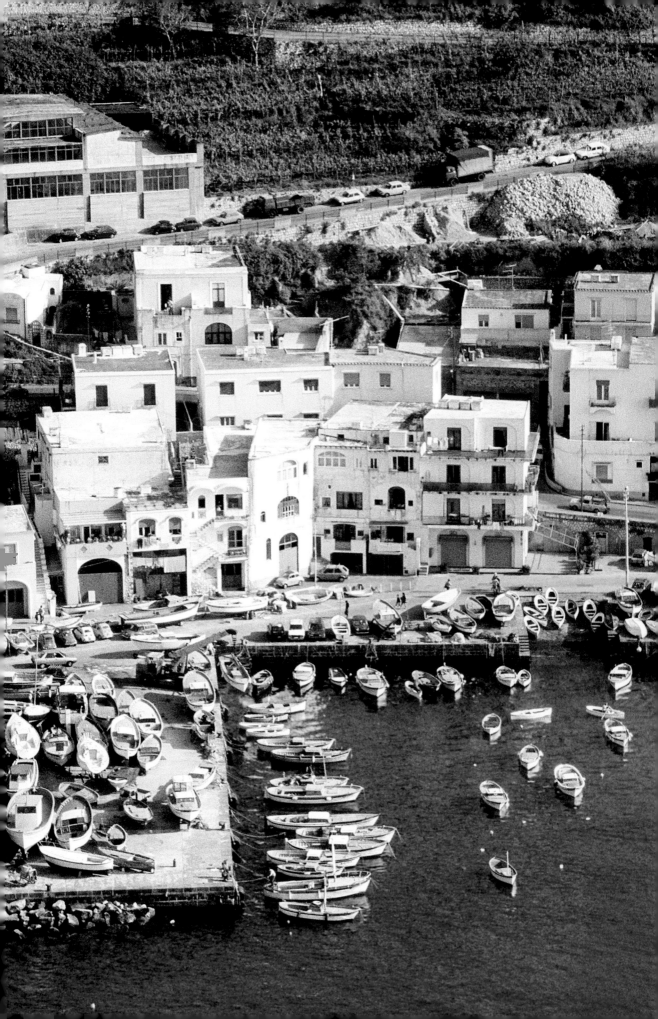

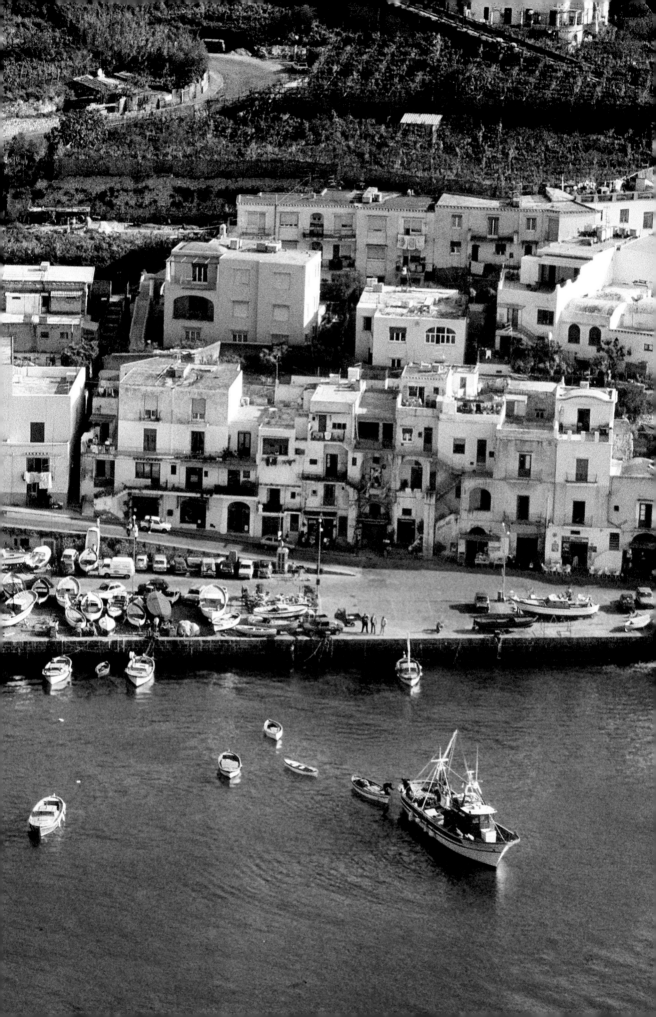

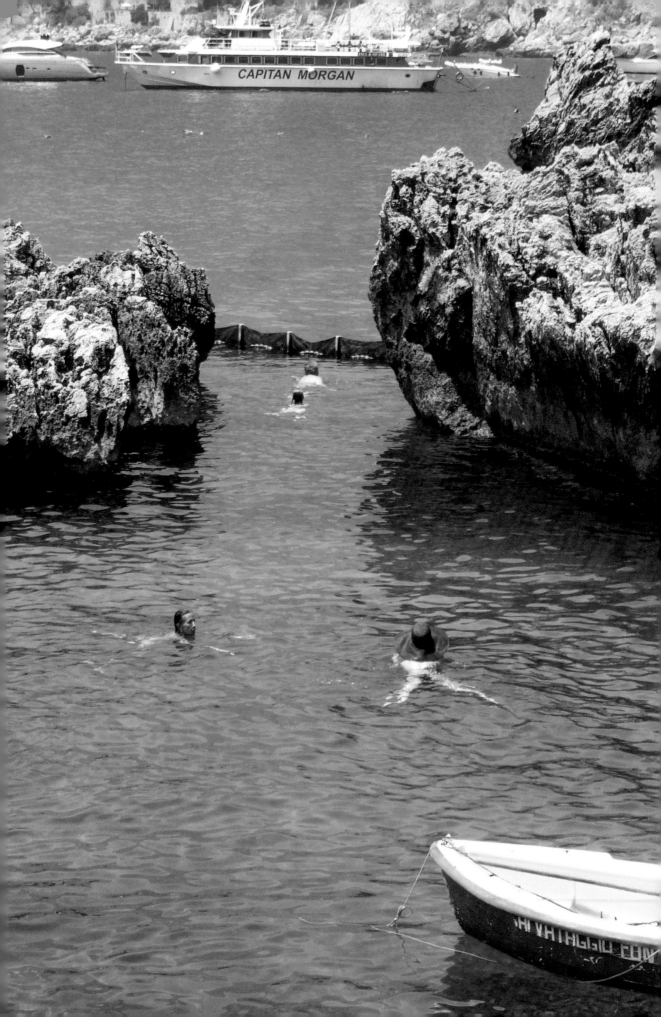

Introduction:
Reflections on a Golden Isle

Capri has probably seen more dramatic events and more extraordinary people on its own soil and in the vicinity than any other small island in the world.
ARVID ANDREN, 1980

If I could create the island of my dreams, I could not improve on one that already exists. I mean, of course, Capri. Everything about it appeals to me, beginning with its manageable size—a bit more than four square miles, easily explored—and including its rocky shape and sheer cliffs. Getting there by hydrofoil is fun (except in rough waters, when it is *anything* but fun), and once you've arrived, you feel blessedly removed from the rest of the world. Capri has a rich, lusty history; indeed, it is the most ancient resort on Earth, a place where Roman emperors romped. And to this day the romping goes on, albeit more gently.

Capri is also heart-stoppingly beautiful, jutting proudly from the Mediterranean Sea like a miracle of nature with its bright flowers, graceful gardens, dramatic promontories, and deep caves, the most famous of which is the Blue Grotto. And because cars are prohibited in the main town, you must walk everywhere. At night those walks become romantic strolls, with couples of all ages holding hands, sometimes pausing to embrace. No one seems to be in any rush to be anywhere (in fact, Capri has long been known as the island of *dolce far niente*, which means "sweet idleness"). There's not a neon sign in sight, and while there is noise, it is the happiest kind. Even the beep of the electric carts is more of a playful nudge than an angry warning to get out of the way.

The food is not what you would call gourmet, but it is simple and delicious—exactly what you want (but don't often get) at a beach resort. There's nothing pretentious or overwrought about it. The tomatoes taste good, the mozzarella is fresh and creamy, the cherries are sweet, the fish fairly leaps from the sea onto your plate, and the pastas are sublime (I often daydream about the *linguine alle vongole*).

Previous Pages: Marina Grande, Capri's main harbor. *Opposite:* Taking a dip at the beach of La Fontelina.

There is also glamour galore on Capri. Paparazzi photos of celebrities who have gone there, from Audrey Hepburn and Grace Kelly to Valentino and Giorgio Armani, are proudly displayed on the walls of practically every restaurant and nightclub, a reminder of the island's allure. Each season brings a new generation of glamour-pusses of both sexes who mingle in the outdoor cafés in the Piazzetta, Capri's main square, hiding behind their sunglasses and sipping their limoncellos.

The boutiques on the Via Camerelle display the latest fashions in a seductive way, beckoning you to cross their thresholds. Within the vitrines of the many jewelers are what appear to be undersea treasures of coral, aquamarine, and turquoise encrusted with diamonds and pearls. If you prefer minimalism and restraint, head for some atoll in the South Pacific. Capri is clearly not for you.

But Capri definitely is for many others, who go annually, in good economies and in bad, because the island's mythical Sirens' song pulls them as strongly as it did Ulysses of Homer's *Odyssey*. The New York–based jewelry designer Amedeo Scognamiglio, one of many people I interviewed in the course of researching this book, sums it up as well as anyone:

"I love Capri because it is not a resort; it's a world apart —*uno scoglio in mezzo mare* ('a rock in the middle of the sea')—with its solid rules (you can't walk around in tank tops or noisy sandals) and the ancient, almost tribal energy of the Capresi. The island is still run by the locals, nobody else, and they do a great job of keeping it true to itself. Capri in all its beauty was not conceived by a designer or an architect. In Capri, nothing changes, as Capri itself doesn't change. When you come back to Capri, the moment you enter the Piazzetta from the *funicolare* (cable railway), you see familiar faces all around you: the always smiling waiters at the bars, the well-tanned and bejeweled ladies having their coffee, and their husbands in white pants with red cotton sweaters tied around their shoulders; the taxi drivers, the shopkeepers, and the porters, year after year, generation after generation."

Capri endures.

Oh, one last thing: It is pronounced *cah*-pree.

Previous Pages: Flowers abound in Capri. *Opposite:* Steps from the view of the Faraglioni, in front of the Punta Tragara Hotel, to two private beaches along the sea.

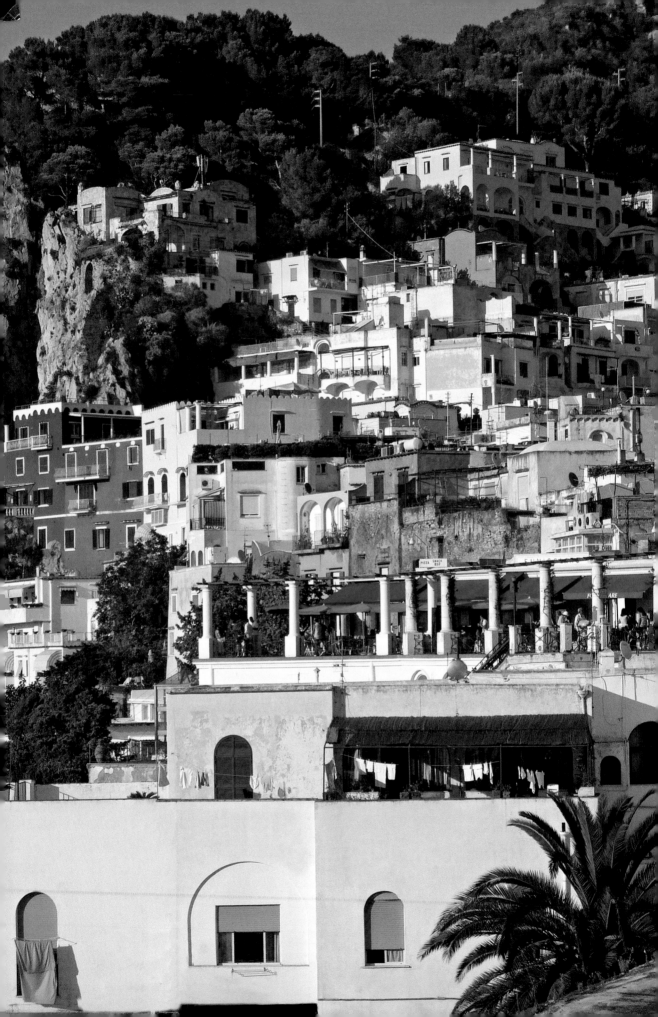

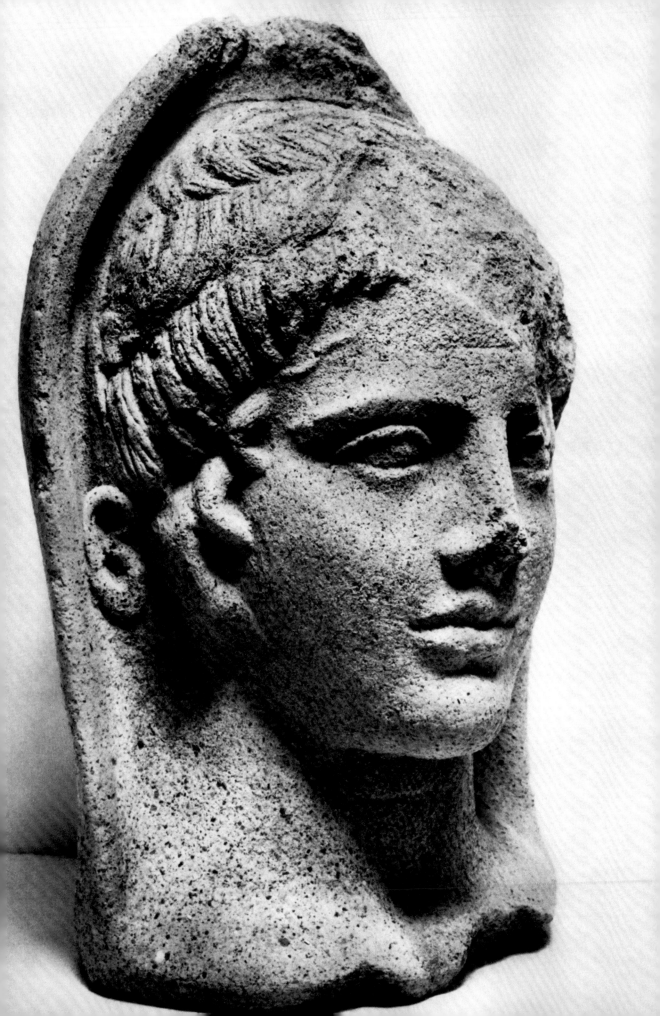

Sirens and Spirits

Capri is both a lump of rock and a flower garden. Ships resounding with music converge from all sides on the island where ancient and invisible gods still seem to live, although during the peak season thousands of visitors are disembarking every day on the Marina Grande and must actually disturb the idyll. In spite of this there is solitude and quietness on Capri. That is its secret.
KASIMIR EDSCHMID (1961)

Capri has many secrets. No one is even sure how it came to be. Like those of the mythical island of Atlantis, Capri's origins are unclear, and this only adds to its mystery. To the best of anyone's knowledge, Capri was once attached to the part of the mainland known today as the Sorrento Peninsula, which includes the towns of Sorrento and Positano and the Amalfi Coast. Apparently it separated from the peninsula about ten thousand years ago during a period of global warming (even then!). In 1906, during excavations performed to enlarge the Hotel Quisisana, a local naturalist and doctor, Ignazio Cerio, discovered the remains of prehistoric forms of elephants, rhinoceroses, bears, and tigers, though how and why these creatures made their way to southern Italy in the first place is puzzling, to say the least.

The first evidence of humans—their weapons, tools, and pottery—was found in Anacapri, the village above Capri town. These people are said to have been early Greek colonists (called Teleboians) who arrived there starting in the eighth century B.C. According to certain sources, among the things the Teleboians built was the stone stairway known as the Phoenician Stairs (Scala Fenicia). Despite its name, it seems the Phoenicians did not construct this steep and strategic passage (some even doubt that the Phoenicians were on Capri at all), which for years was the only way to get from the Marina Grande, where the commercial boats and many pleasure craft arrive, in Capri to Anacapri. That meant navigating its seven hundred and some steps, sometimes more than twice a day and often while bearing heavy and cumbersome supplies. In recent years only the heartiest souls have ascended these steps, usually to prove that they can—not unlike Sir Edmund Hillary, whose motive for climbing Mount Everest was simply "Because it is there."

Previous Pages: The main town of Capri and a watercolor of Villa San Michele, by Bengt Böckman.
Opposite: An early Roman sculpture, one of many such artifacts at Villa San Michele.

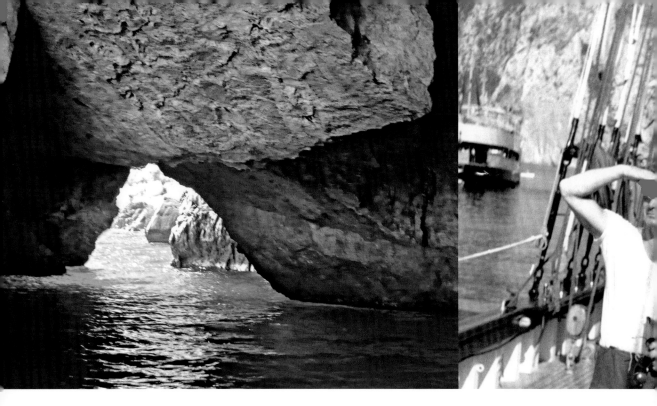

Left: A view of La Grotta Verde (the Green Grotto). *Right:* An illustration of La Grotta Azzurra (the Blue Grotto).
Center: Hollywood actress Rita Hayworth and her husband, Prince Aly Kahn; taken aboard Errol Flynn's yacht in 1949.

Capri is not exceptionally large—four square miles, or a little more than 2,500 acres—and juts out of the Tyrrhenian Sea, a tantalizingly beautiful slice of the Italian Mediterranean. It has hills and slopes and rugged terrain that is punctuated by bougainvilleas, geraniums, orange trees, and olive groves. There is so much overgrowth that even many of the grandest villas cannot be seen from any distance. The island has no skyscrapers; indeed, the nearest tall buildings are across the water in Naples, too far away to be aesthetically disturbing.

Because so much of it is limestone, an abundance of natural caves is among Capri's distinctive geographical features. The most notable is the Blue Grotto (Grotta Azzurra), where the Romans worshipped their mythical water nymphs. After the Romans left Capri, the sea cave, originally called the Grotta Gradola after a nearby landing place, was considered possessed, inhabited by witches and monsters. Since this was obviously impossible to prove or disprove, the locals avoided the area. Not until 1826 was the Blue Grotto "rediscovered," by a native fisherman, Angelo "Riccio" Ferraro, and August Kopisch, a German poet and painter. (As the story goes, the pair were encouraged to seek out the grotto by the local notary and hotelier Giuseppe Pagano, who owned what is now called the Hotel La Palma and is the island's oldest lodging, and who wasn't about to venture there himself.) What sets this particular cave apart from many others on Capri is its water's brilliant azure color, caused by the sunlight refracted against its walls. To this day the Blue Grotto remains one

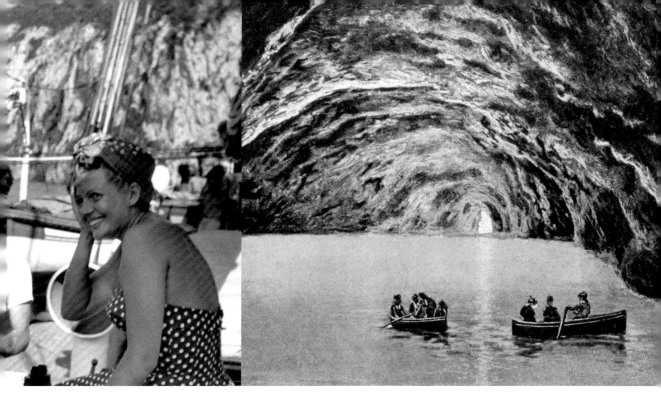

of Capri's claims to fame, touristically speaking, and no first-time visitor to the island should miss seeing it (although, as with many such shrines, once may be quite enough). Swimming in the grotto is now prohibited—the currents can be rough and dangerous— but not so long ago the cave was an aquatic playpen for rambunctious teenagers, who like to go where they are forbidden to, and for decadent adults who had many an illicit romp within the Blue Grotto's incandescence. Such rompers were known by those who disapproved of them as the *grottazzurificazione*—the Blue Grotto-izers—of Capri.

Probably the island's most characteristic and visible natural feature is its three dramatic side-by-side rock formations, known as the Faraglioni, which rise from the sea like primitive sculptures. They are to Capri what Mont-Saint-Michel is to the coast of Normandy or the Statue of Liberty is to New York Harbor: a defining landmark and the stuff of postcards and picture books. But while the Faraglioni are familiar, the sight of them still makes one's heart skip a beat. Small boats and water-skiers routinely weave their way around and through the formations, one of which is populated by rare blue lizards.

There are several theories about how the island got its name. A popular one is that "Capri" comes from *kapros*, the Greek word for a wild boar. But the most widely held theory is that it derives from the Latin for "goats"—*capreae*—which would explain why Capri is often referred to as Goat Island. Not a very sexy name for one of the world's most romantic places.

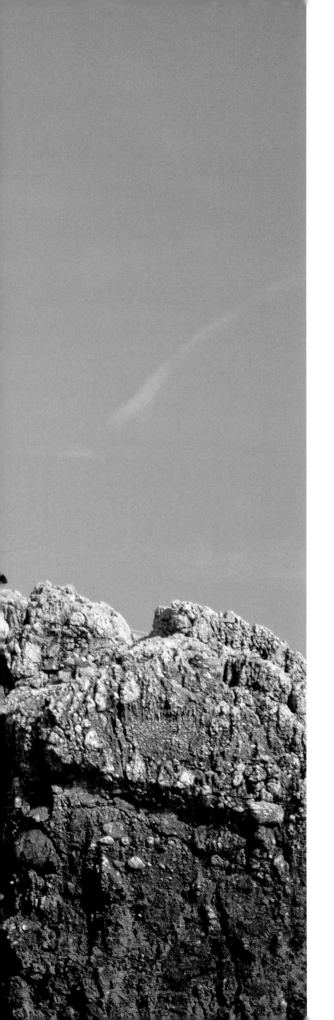

The myth about Capri being the island of the Sirens goes back to Homer's epic tale *The Odyssey*. As Ulysses (aka Odysseus) was making his arduous way back to Troy, he and his crew resisted one temptation after another, so intent were they on returning home. At one point the ship was about to go through an area where the Sirens were said to sing seductively—so seductively that Ulysses resorted to tying himself to the mast and filling his men's ears with wax, lest they be coaxed into dashing themselves to death on the rocks. Those rocks are thought to be located off Capri, though exactly which ones they are is still disputed. Such is the mythic "history" in which the island abounds.

Left: Swimmers and fishermen use the rocks of Capri as their perches.
Following Pages: The legendary Faraglioni, the island's distinguishing rock formations.

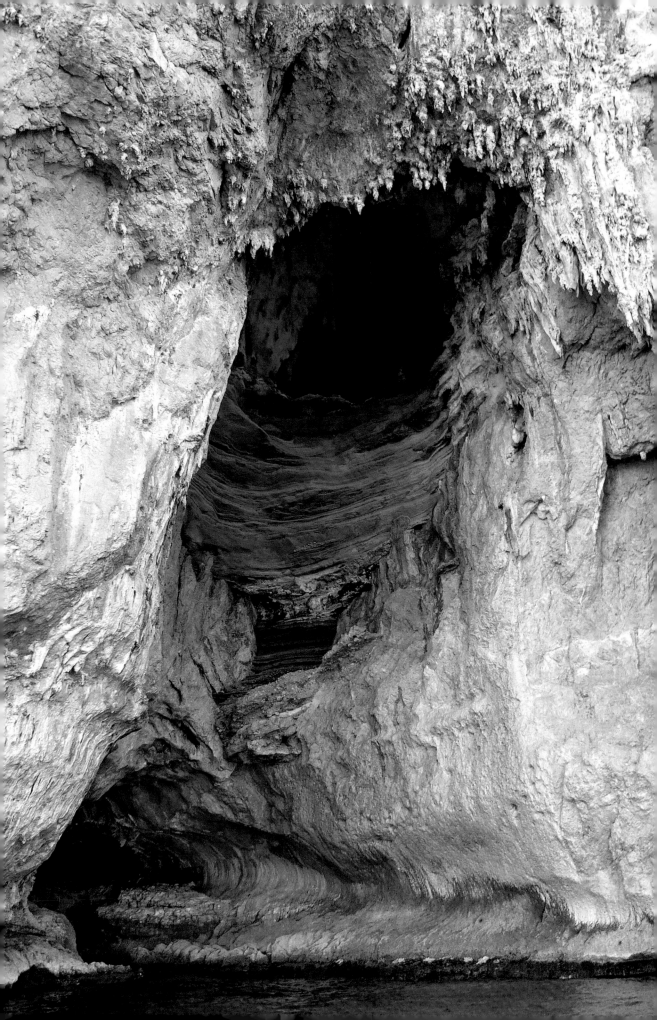

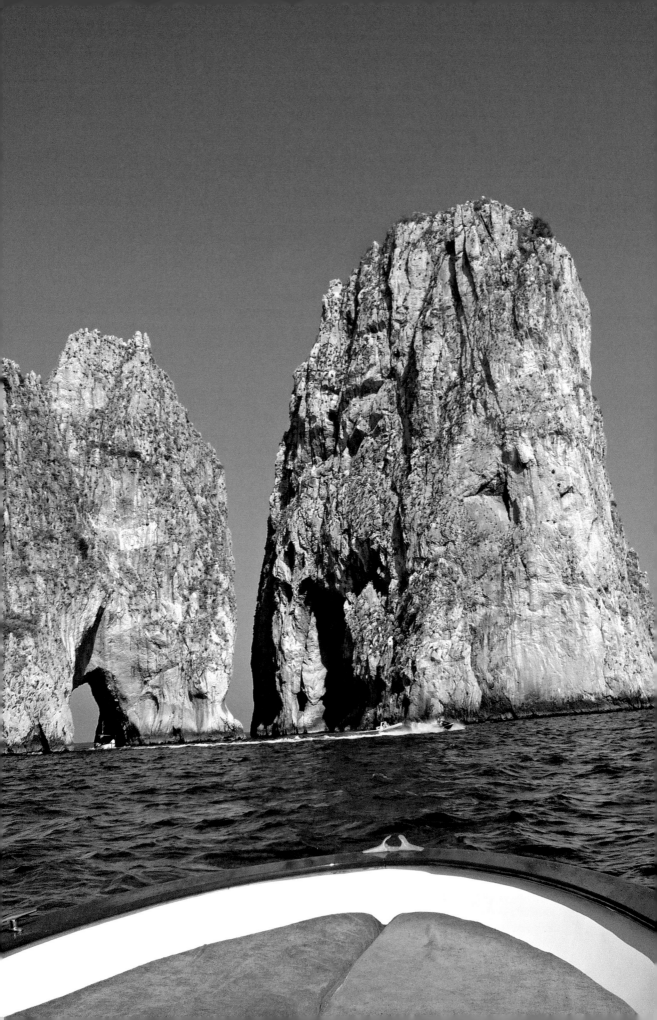

"*There is something about Capri that is enchanting and in all of those years of going, I have never once been to Ischia, even though I always say, 'This year, I'll go to Ischia.' When I get to Capri, I just never want to leave the island. In all of my years of going to Capri—always staying at the Quisisana— I never skipped a summer.*"

ELAINE FABRIKANT

"*The charm of Capri then, and even now, is that little by little you become part and parcel of life on the island; and as small as it is, there are always new discoveries.*"

CYRIL DWEK

"My favorite thing to do is to walk in Capri at night, especially to go to the restaurant Le Grottelle during a full moon. You must go on foot—and wear good shoes, because it is not such an easy walk. The moon in Capri is not like the moon that you see anywhere else—they call it luna rossa, *the 'red moon.'"*

NATASHA DE SANTIS

"I first went to Capri with my friend Enzo Albanese. Canzone del Mare was the hot place then. There were Riva boats in the harbor. We went water-skiing through the Faraglioni. I'll never forget it. We've been going back ever since."

JOHN SCHUMACHER

A Resort is Born

If there is a paradise on the face of the earth,
It is this, oh! It is this, oh! It is this.

ANONYMOUS

Capri is the world's first resort, dating all the way back to the rule of the Roman emperor Augustus, more than two thousand years ago. In 29 B.C., the ship bringing him home from a war in the east landed on Capri. At that time the island was under Naples's dominance. In the kind of real estate switch that only emperors and other wealthy men can make, Augustus gave the nearby and larger island of Ischia to Naples and turned Capri into his private estate, complete with imperial villas. There he sometimes took up residence during the latter part of his forty-three-year rule of the empire. No one knows how often he went or how long these visits lasted, though probably they were few and far between; the only fairly reliable accounts are those of the historians Tacitus and Seutonius, who were not admirers of Augustus and who criticized him and his stepson Tiberius for what they said were the pair's depravities. Much later, in the mid-20th century, Norman Douglas, a longtime resident of Capri who researched and wrote much about the Sorrento Peninsula, came to Augustus's defense and that of Tiberius, who even more than his stepfather was responsible for elevating Capri to the status of "resort" in the modern sense of that word.

The Capresi in those days were more Greek than Roman, owing to their former occupation by that nation; their language was Greek, and so were their manners and mores. Apparently the cultural differences between the Romans and the Greek-influenced Capresi were a source of great diversion for Augustus, and the island became his playground. But while the emperor was enjoying himself, Tiberius sat grumpily on the sidelines and was not amused (probably because he was himself beginning to fall under the spell of Capri). When Augustus died—from either typhus or poisoning—his fiercely ambitious wife, Livia (possibly the poisoner, if there was one), made sure Tiberius, her son from her first marriage, inherited

Opposite: A statue of Tiberius stands vigil over Capri. *Following Pages:* The Roman Emperor Tiberius basking in his licentious glory at Villa Jovis (from a nineteenth-century color engraving).

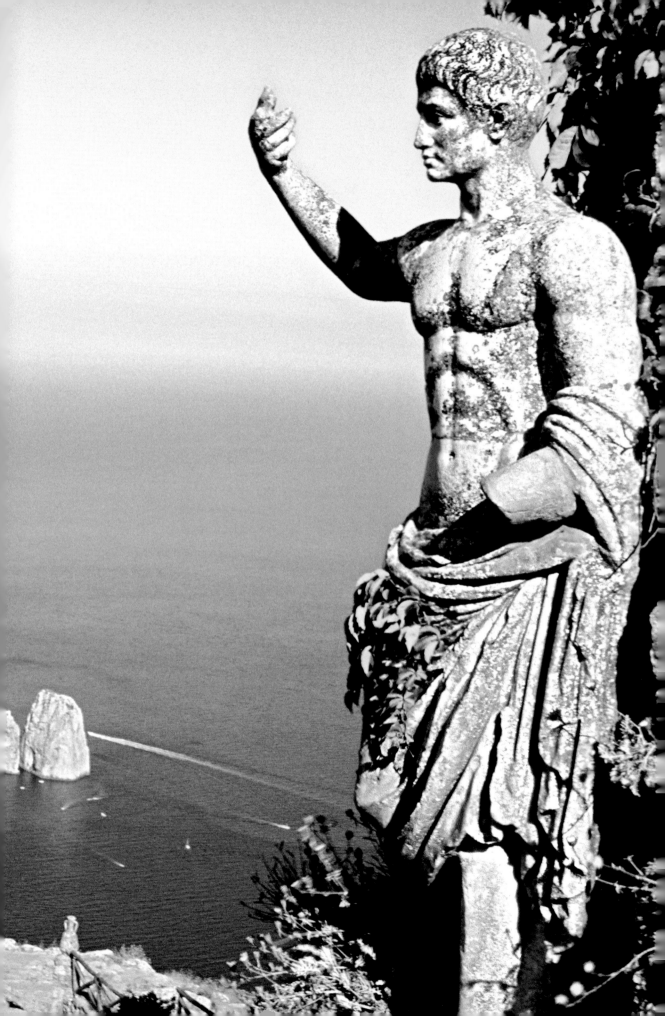

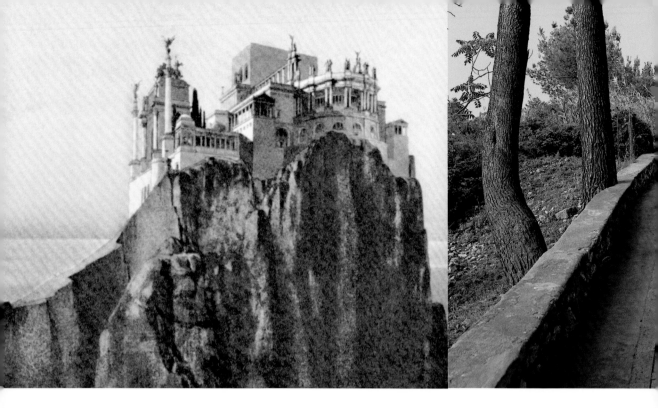

Left to right: A nineteenth-century interpretation of Villa Jovis; a path leading to the Villa; bronze bust of Tiberius from the Museo Nazionale, Naples.

the empire, whether he was qualified or not. With it came Capri, a little piece of heaven. At sixty-seven, Tiberius wasn't exactly robust, nor was he the popular leader his stepfather had been. But he loved Capri and decided to spend the last decade of his rule (between A.D. 27 and 37) on the island. How he led an empire from such a distance is anyone's guess. Nevertheless, he inherited Augustus's villas and chose one in particular to be his imperial residence Jovis, named for Jove (aka Jupiter), the god of conviviality, which makes perfect sense because it was definitely a place that encouraged social—and other—intercourse. Though little of it is left, the Villa Jovis is one of Capri's most frequently visited sights. Salacious stories were told about Tiberius's reign, stories of banquets and orgies, of boys and girls being flung from the overhang known as Tiberius's Leap (Salto di Tiberio) into the sea, just for the sport of it. While today there is online pornography to entertain and stimulate, in the days of Tiberius, there were *tableaux vivants*. Much more palpable, shall we say.

True or not, these tales add greatly to Capri's reputation as a good-time island —if playfully sending innocent youths to their deaths can be considered having a good time; *chacun à son goût*. And if all this sounds just too incestuous, it was. The BBC production *I, Claudius*, based on the novel about Tiberius's successor by Robert Graves, gives a glimpse of the period in all its rivalry and revelry, as does the steamy 1979 movie *Caligula*, written by Gore Vidal and chronicling the frolicking of that randy Roman emperor (was it something in the water?).

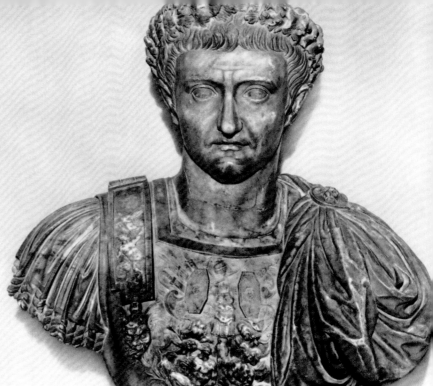

At any rate, the centuries of local licentiousness that have followed make one wonder if the word "caprice" derived from Capri. After all, as Oscar Wilde once said, "the only difference between a caprice and a lifelong passion is that the caprice lasts a little longer." In Capri's case, it cheerfully continues.

Throughout its long history, the island fell in and out of favor with various invaders (Greeks, Romans, Spaniards, Bourbons, and so on) and with sightseers (Germans, Russians, Britons, Swedes, Americans, and the nearby Neapolitans, whom the Capresi never considered their countrymen or even particularly welcome neighbors).

As tourism increased, farming and other local businesses gradually disappeared, and administering to the needs of the outsider became by far the most important and profitable industry on Capri. It remains so, thanks to the tradition established by Emperor Tiberius, who knew a good thing when he saw it.

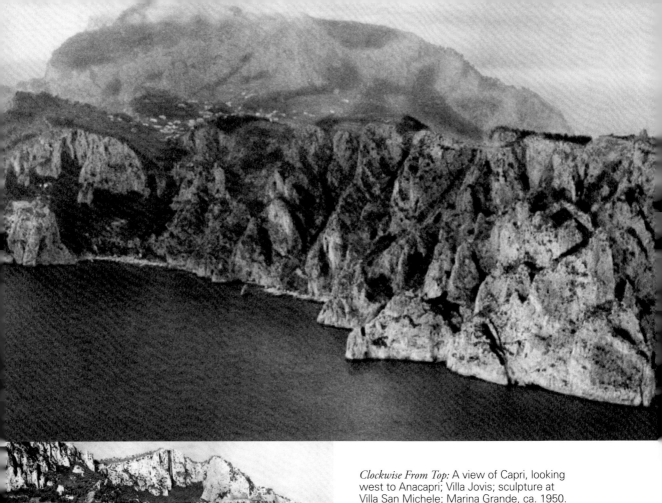

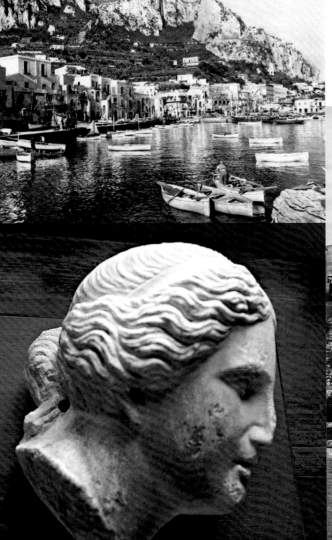

Clockwise From Top: A view of Capri, looking west to Anacapri; Villa Jovis; sculpture at Villa San Michele; Marina Grande, ca. 1950. Opposite: Bust of Emperor Caesar Augustus. Following Page: Detail of a map of Capri painted on ceramic tiles; an aerial view of Villa Jovis.

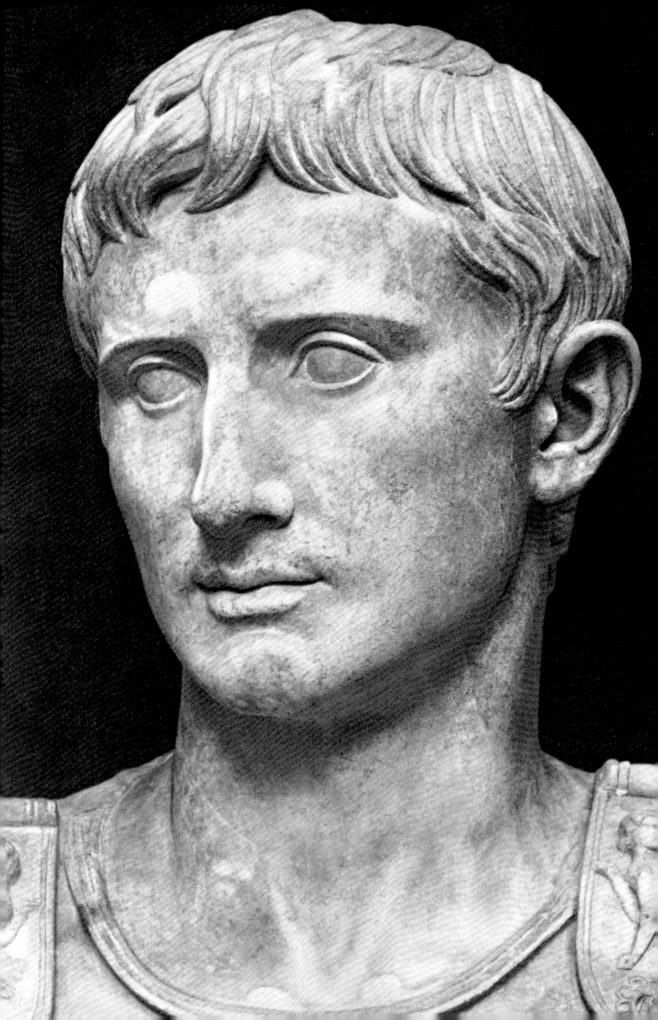

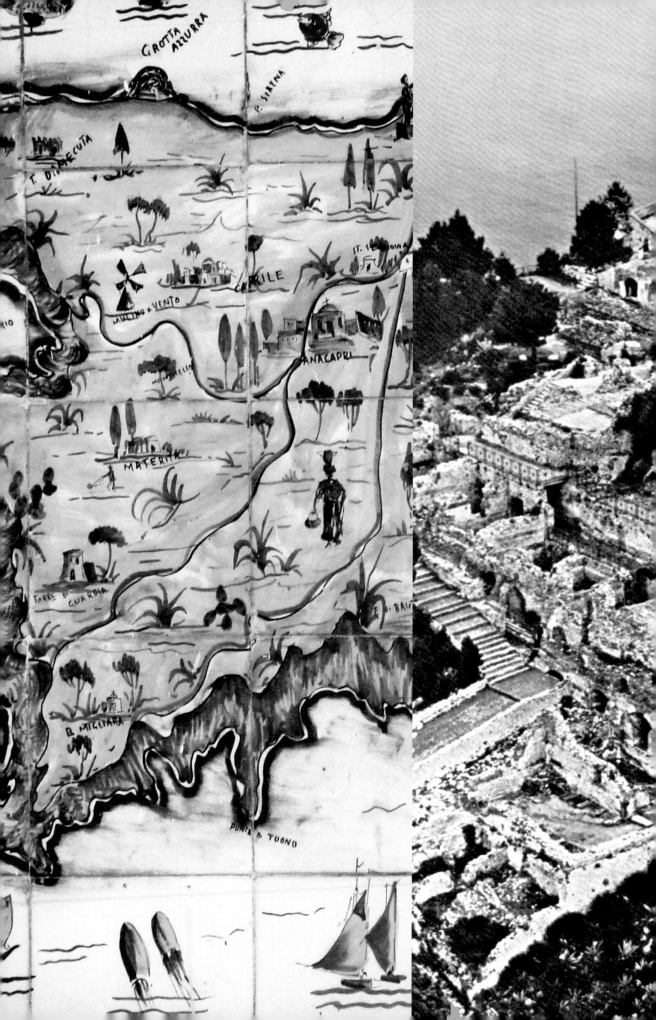

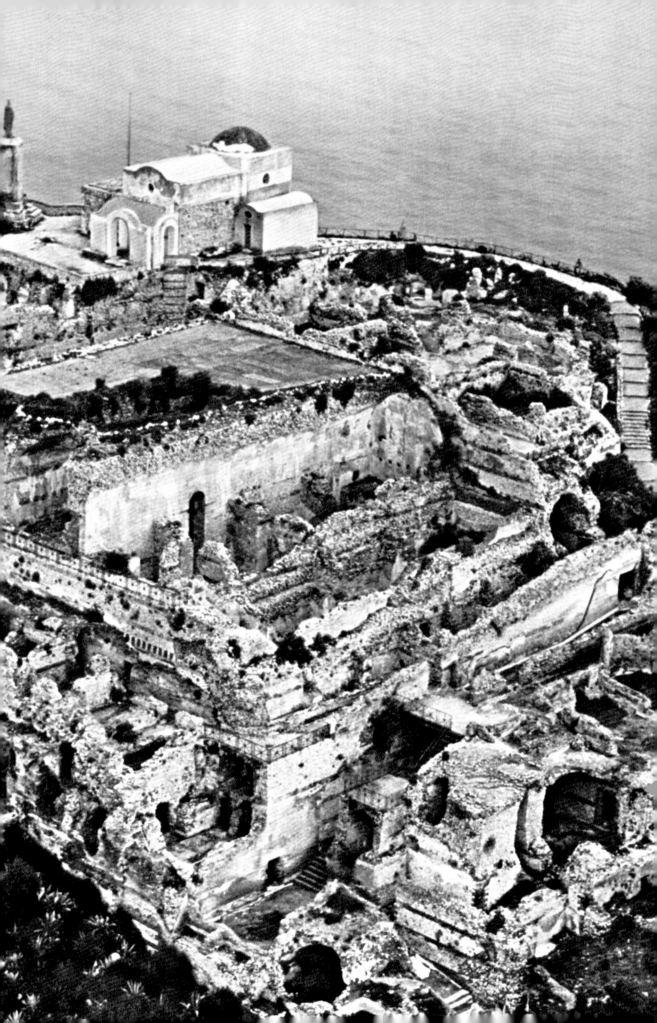

Stroll along the Via Camerelle and the Via Vittorio Emanuele for Pucci, Alberto Aspesi, Prada, Russo Uomo and Russo Donna, Valentino, Roberto Cavalli, and Dolce & Gabbana. Around the Piazzetta are the Car Store, Ferragamo, and La Parisienne, as well as jewelry stores like Alberto e Lina, Chantecler, Dorotea, and La Perla Gioielli. For handmade sandals, go to Canfora, L'Arte del Sandalo Caprese, and Giuseppe Faiella. Go to Via Le Botteghe for the works of local artisans. Flair, a new design store, can be found near the bus and taxi stops.

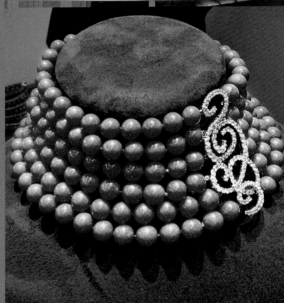

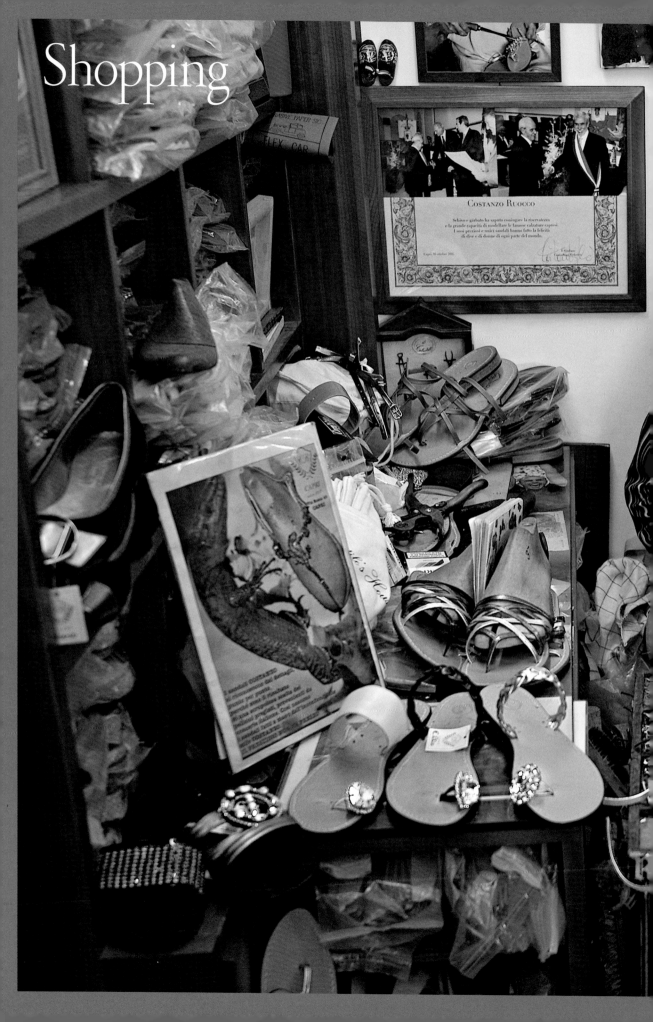

Shopping

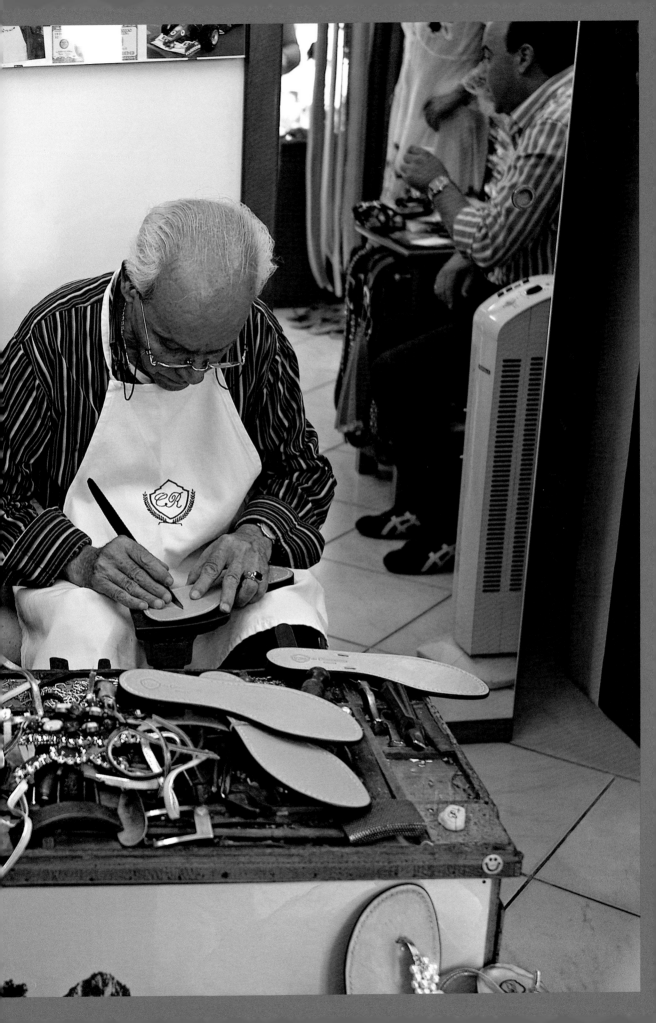

The Capresi

The island's geographical configuration is such that it looms everywhere, and you begin to wonder 'Where are the homes, where do they live?'

RAFFAELE LA CAPRIA

It's true that the houses on Capri seem hidden, tucked away in crevices and out-of-the-way corners within labyrinths of vegetation, up high and out of reach. It's also true that finding one to buy is almost impossible. The islanders like to keep their homes within their families and are loath to sell them to outsiders. And when they do, they set prices so exorbitant that few can afford them. One new homeowner who is not a local is Gianluca Isaia, a Neapolitan menswear designer. His house has a view of the Marina Grande. He says he owes this happy outcome to his "good connections" and admits that it is unusual for a Caprese to sell to a foreigner. "I am from Naples," he explains, "so I am a foreigner." No matter that he has been going to Capri since he was five years old.

Because Capri is an island, and a small one at that, there is a familiarity and an insularity among its twelve thousand full-time inhabitants. The Capresi, as those born and raised here are called (or, in English, Capriotes), all know one another. They grew up together, attended the same schools, and continue to socialize, family feuds notwithstanding, into adulthood. But they're also accustomed to invasions, having frequently been occupied by other civilizations—a history that perhaps has prepared them, as a culture, to become a tourist destination. Capri attracts throngs of visitors in high season, from cruise ships, from the Sorrento Peninsula, and now from all over the world. But unlike the inhabitants of some places, who have become world-weary and even resentful of outsiders, the Capresi remain mostly cordial, probably because they realize how necessary tourism is to their economy. They are almost completely dependent on it, and the Italian adage *Non mordere la mano che ti nutre* ("Don't bite the hand that feeds you") may well sum up their attitude.

In his 1933 memoir, *Looking Back*, Norman Douglas describes the Capresi in this way: "The indigenous population falls into two distinct classes; the real natives, who own property

Previous Pages: A highly revered Capri craft: the art of sandal-making. *Opposite:* Tonino Cacace, owner of the Capri Palace and Spa, among the pleasure boats at Marina Grande.

41

on the island, whose ancestors were born there, and who ask for nothing save to be allowed to go on with their work in peace; and a race of newcomers, immigrants from the mainland who settle there for longer or shorter periods, attracted by the tourist-traffic." Although Douglas refers to most outsiders of the day as "decent folk," he quickly adds that a fair number are "impoverished adventurers, unscrupulous and malicious, with no reputation of their own to lose and no respect for that of others."

Mario Soldati gives a far less charitable view of the islanders in his 1966 novel *Le lettere da Capri* ("The Capri Letters"): "The local Caprese stoke up the embers, too. Indefatigably, they carry twigs and branches thorny with malice, blow on the flames of envy, watch, point, laugh. They do this partly from financial self-interest, for the foreigners are their livelihood, but partly also from a certain natural inclination: they themselves are decadent and decayed: gossips, spies, traitors, liars, corrupt, actors, sophists, hysterical and torturous; in fact, profoundly corrupt and unhappy like so many southern Mediterraneans."

Harsh criticism, but not entirely unwarranted. Cynicism inevitably sinks in when tourists converge on a small

Peter Cottino, who oversees Villa San Michele, Anacapri's most important tourist site.

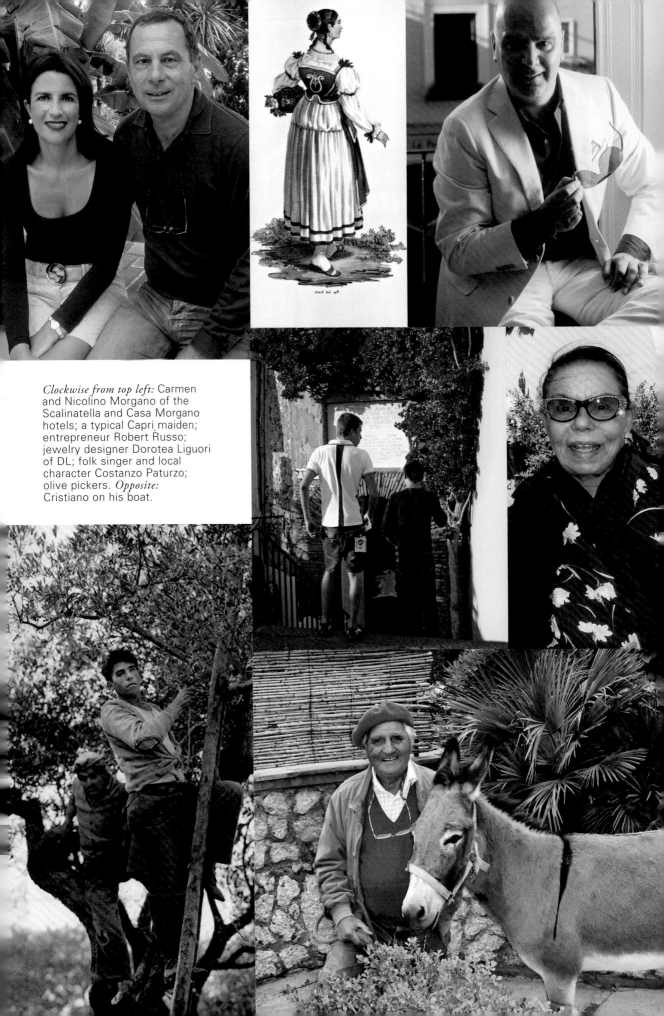

Clockwise from top left: Carmen and Nicolino Morgano of the Scalinatella and Casa Morgano hotels; a typical Capri maiden; entrepreneur Robert Russo; jewelry designer Dorotea Liguori of DL; folk singer and local character Costanzo Paturzo; olive pickers. *Opposite:* Cristiano on his boat.

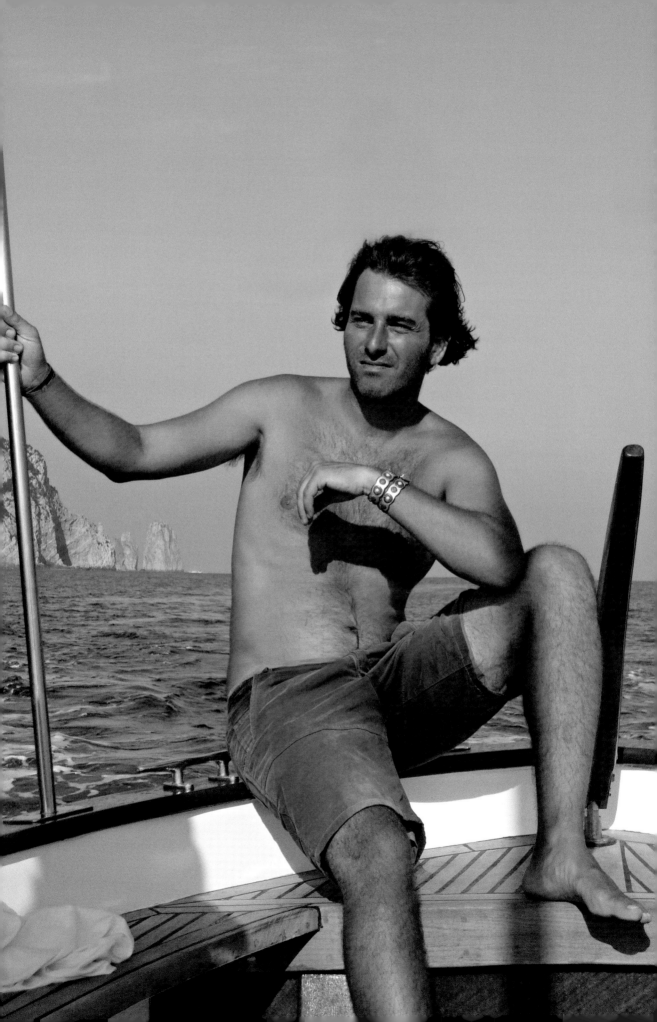

island such as Capri for a sliver of the year, have their good time, enjoy the hospitality at hand, then vanish, leaving the natives to their own devices in the dreariest season: winter.

In most seasons, Capri is an immensely pleasant place to be, having mild weather, soft sea breezes, lovely aromas, and plenty of sunshine. Not so in winter. In his memoir *Capri e non più Capri* ("Capri and No Longer Capri"), published in 1991, the Italian writer Raffaele La Capria describes it thus: "The winter in Capri is trying. The island becomes a dark and hostile rock, battered by rain and wind. In the evening, not a soul ventures out, and it is cold, a damp relentless cold because southern Italian houses simply have no heating and the problem has always been dealt with in an inexact way."

Grazia Vozza, who designs jewelry and has a lovely boutique on Via Fuorlovado, wasn't born or raised on Capri, but she and her husband have lived there for several years. "We love Capri," she says, "but in summer, we are always so busy—with the boutique, social life, family; then winter arrives and it becomes too quiet. There is no balance."

This is when living in paradise becomes more of an ordeal than a privilege. The main square, known as the Piazzetta, is deserted; the hotels and restaurants are pretty much closed for the season; and transportation between Capri and the mainland is reduced, mostly because the waters are too rough to navigate. There have even been blackouts during these months of isolation, events that bring the entire island virtually to a standstill.

But the Capresi stick it out, and some even claim that winter is the best time to be on the island. As one person said, "the light in the Marina Piccola in January, February, and March is so beautiful, and there is a good walk from the Blue Grotto to the Faro ("Lighthouse"), where at one point you find yourself walking under the trees."

Carmen Morgano was born on Capri near the Villa Jovis. She is married to the hotelier Nicolino Morgano and is deeply devoted to the island. "You can only truly understand how beautiful Capri is when you leave it," she says. "Everyone loves Capri, but not everyone knows how to *live* in Capri." But even she admits that it can be challenging at times. "In winter, you can't ask of the island what the island cannot give to you. It gets dark early, around five in the afternoon. The square, because it is open, can get very windy. My birthday is November 21, but I can't ever have a party at a restaurant, because nothing is open, so I end up cooking for myself.

She continues, "Capri is always dependent on weather: The sun is our gasoline, our power. If we cannot sit outside, we feel deprived. And sometimes we have to go one or two days without food or milk deliveries to our stores, which is why so many people grow their own vegetables."

A Caprese who likes to talk of the early days on Capri is Costanzo Paturzo. He was born on the island in 1933 and resides high up in the hills near the Villa Jovis. The only way to reach Costanzo's home is to take a long walk or, if you are lucky, hitch a ride in his electric cart. The longtime head of a popular folk-music group called Scialapopolo, which performs locally and, on occasion, off the island, he has the personality and charm of a born showman. But when he speaks of Capri just prior to World War II, his face falls. "Before the war," he says, "there was essentially no tourism. To live here was very hard. There wasn't any water or lights (so the planes couldn't see us at night, which was in some ways a blessing). I was the sixth of eight children. Back then we lived near the Piazzetta. One day my mother was bringing home groceries when a bomb went off. She died. I was only ten."

Costanzo was sent to live in an orphanage in Rome until the war was over. "After the war, the Americans and English came here," he says. "Many *caprese* women fell in love with them. The women were looking for love, but also for food; after all, we were eating the skins of potatoes here."

According to Costanzo, that's when tourism began in earnest: around 1950. At this point his eyes light up again. "*Tutti la gente che viene a Capri stanno bene*," he says with a smile. "Everyone who comes to Capri stays healthy." And he believes it.

Roberto Russo is, by a long shot, the most successful entrepreneur on Capri. "I am pedigree *caprese*," he says proudly. "I was born in a house directly in front of the Quisisana where my mother, father, and grandfather were living. I lost my father when I was in my twenties; he was only fifty-eight. He was a friend of Roberto Rossellini, and when Rossellini and Ingrid Bergman were together, they would stay at our house. It was so long ago that most people didn't even recognize them.

"In 1868, my grandfather opened the first food store on Capri," he says. "It was called Russo Emporio. Our flagship store was Russo Uomo, a men's boutique. Now we have twenty-two shops, plus a restaurant called Edodé, a sports center, a specialty-food shop, and a tennis club. I have three hundred people working for me."

Russo insists that Capri is one of the world's safest places. "Families still go to sleep without locking their doors. The Mafia isn't interested in Capri, because it's too small and they can't do business the way they want. Capri is perhaps the only place in the world where if you're famous, you can feel completely free to walk without chaperones or bodyguards." Angelina Jolie and Brad Pitt, take note.

"My husband, David, and I were married in the Chiesa Santo Stefano, which overlooks the Piazzetta, on July 20, 2001—my thirtieth birthday. I was the last non-caprese bride to be married there; now you have to have been baptized in the church in order for that to happen. When I was little, I would sit in the Piazzetta and vow that I would get married in that church. It was meant to be."

MARISA MAY

"My first time in Capri was with Marisa Berenson in, I believe, 1967 or '68. We were barely twenty. Marisa was already a famous model. I was no one. She had been invited to attend Mare Moda and get an award; she asked me to come with her. George Hamilton was there with a beautiful girlfriend, Alana, who became his wife. There I also met Valentino and lots of gorgeous Italian playboys. It was la dolce vita *time."*

DIANE VON FURSTENBERG

“*It was 2003 and I was trying to find a place to go to that was self-contained. Whenever I am there, I do the same thing every day. I am a creature of habit. The staff at the Quisisana knows me and my routine: I have my martini on the terrace at 8 p.m. on the dot (the waiters even know what I want: Ketel One, very dry, with olives; I love that). Around nine-thirty, I'll go to Aurora or to La Capannina; the man who owns it is always so cheery and welcoming. After dinner, I go to the Bar Tiberio in the Piazzetta. The waiter usually sees me coming and knows exactly where I want to sit and what I want to drink.*

During the day, around ten, I go to the beach at La Fontelina, to the same spot—in the center, down a few levels, so I can watch the people. I wander up to the restaurant at about two and always have two courses, wine and, to finish, a limoncello. I stretch out the lunch for as long as I can and then back to the beach. Because of all the steps leading to and from La Fontelina, I have never gained weight in Capri. It is also the most spectacular walk in the world.”

JIM BRODSKY

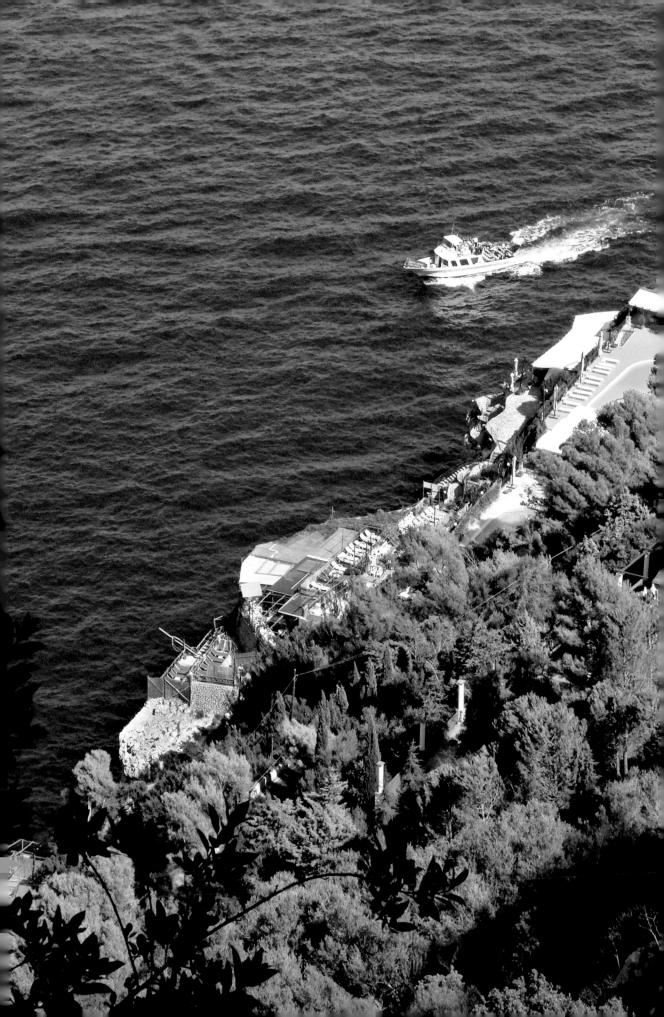

The Other Capri

Topped by the pale tint and faint, suggestive scent of ginestra, a yellow flower (known as broom in English) that looks as though a piece of the dawn had crumbled, the village of Anacapri appears to have a light of its own, muted at times, flagrant at others, coy and flirtatious in its passage through the day.
PETER FEIBLEMAN, 2005

Between those who live in Capri town proper and those who reside in Anacapri, the village above—and, in some ways, apart—there is a distinct difference and even a certain rivalry. The residents of the former consider themselves merchants: worldly and sophisticated, industrious and clever. They regard the Anacapresi as rural, perhaps a little backward and isolated (a vestige, no doubt, of the days when the only way to get from one village to the other was via the Phoenician Stairs). The truth is that Anacapri is mere minutes away from the Piazzetta along a winding road with spectacular views.

Still, Capri and Anacapri each have their loyalists, who are content to stay put in their town of choice for weeks at a time. This is especially the case with Capri regulars, who boast that they can spend a month at the Quisisana or Scalinatella without once going up to Anacapri. Too bad. They are missing something.

According to Roberto Russo, the relationship between the towns is now more symbiotic than competitive. "It's true that Capri has more glamour and is more expensive, and that the real estate is better than in Anacapri," he says. "There used to be a rivalry between the two, but not any longer. The joke was that you needed a passport to go to Anacapri. The truth is that the two towns need each other."

For those who don't want crowds and couldn't care less about shopping in brand-name boutiques but still want to be on one of the Mediterranean's most beautiful islands, Anacapri may be just the place. To get there, you must go by bus or open-air taxi along a curvaceous road, hoping all the way that your driver has a clue what he is doing. The two-lane road is narrow, and passing on it is perilous, though this fact doesn't seem to deter anyone. But experience the road often enough and you'll

View of seaside restaurants from Anacapri. *Following Pages:* One of many fresh lemonade stands in Anacapri, ca. 1930s.

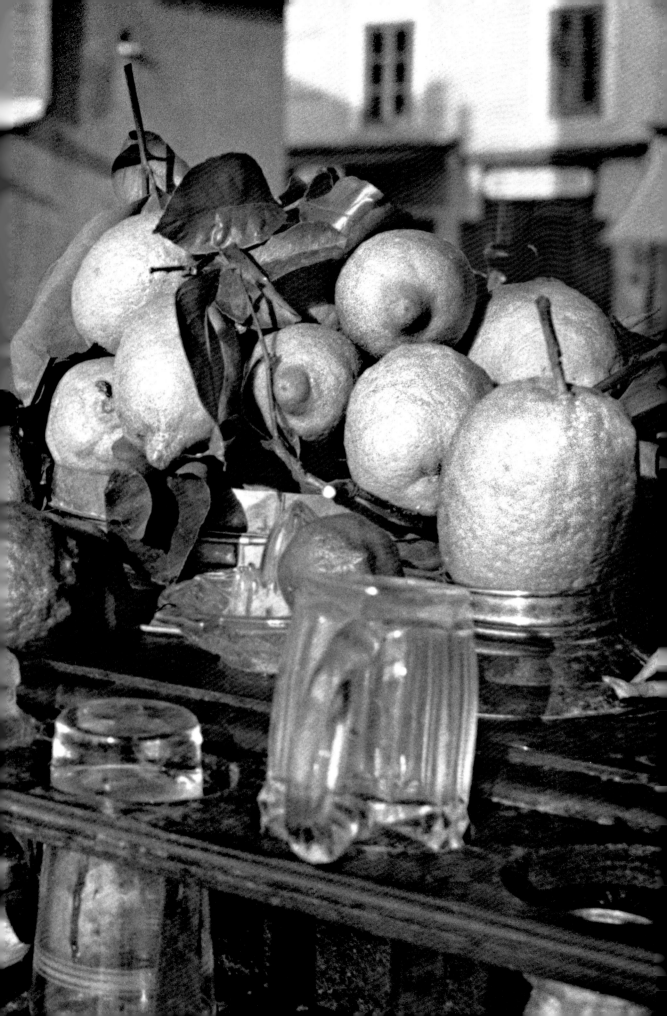

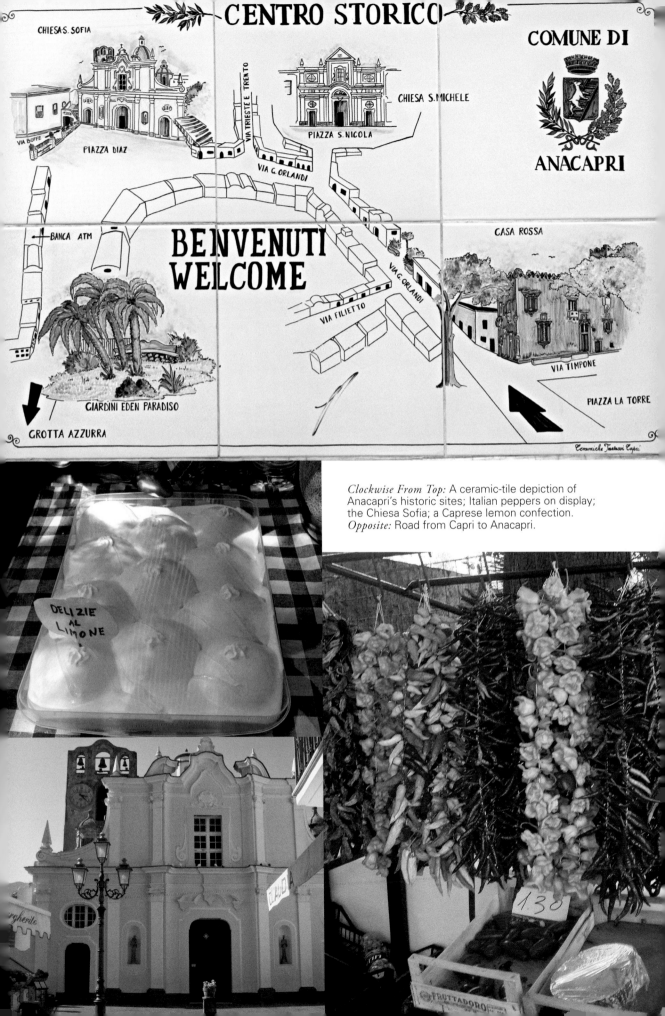

Clockwise From Top: A ceramic-tile depiction of Anacapri's historic sites; Italian peppers on display; the Chiesa Sofia; a Caprese lemon confection. *Opposite:* Road from Capri to Anacapri.

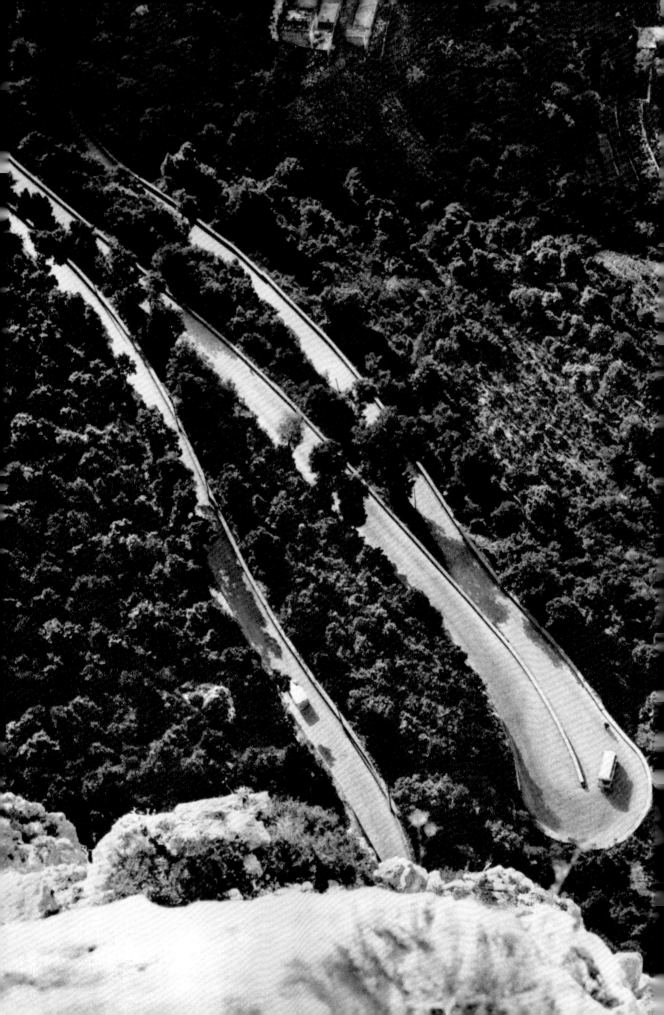

become accustomed to the drama and be distracted by the awe-inspiring views. Of course, you can always take the Phoenician Stairs to Anacapri. Until the main road was built, those seven hundred and seventy steps were the only way to go from one village to the other. Hikers do it; most humans don't.

When the road levels out, you enter Anacapri, a small town with a quieter charm and, in high season, plenty of tourists, who are there to take the chairlift to Monte Solaro, the island's highest point, or to visit the Villa San Michele, the famous castle of the Swedish-born doctor Axel Munthe, who wrote a memoir that was a best seller in the late 1920s and 1930s. It is called *The Story of San Michele* and is not only Munthe's tale of rebuilding what was once one of Tiberius's villas but also a doctor's recollection of an era in Europe when diseases such as typhus and cholera were at epidemic levels.

In the book's first chapter, Munthe describes the view that he beheld from Anacapri on his initial trip there in the early 1920s: "The whole bay of Naples lay at our feet encircled by Ischia, Procida, the pine-clad Posilipo, the glittering white line of Naples, Vesuvius with its rosy cloud of smoke, the Sorrento plain sheltered under Monte Sant'-Angelo and further away the Apennine mountains still covered with snow."

It was also then that he saw the villa which would become his home. "I looked at the little house and the chapel. My heart beat so violently that I could hardly speak. To live in such a place as this, to die in such a place, if ever death could conquer the everlasting joy of such a life!"

And so began the Swedish doctor's love affair with the Villa San Michele. He purchased it from the owner, one Mastro Vincenzo, who admitted that he was getting too old to take care of the property and that he was ready to sell it. Vincenzo and his sons, however, helped Munthe rebuild the villa according to the doctor's rhapsodic vision: "I want columns of priceless marble, supporting loggias and arcades, beautiful fragments from past ages strewn all over my garden, the chapel turned into a silent library with cloister stalls round the walls and sweet-sounding bells ringing *Ave Maria* over each happy day."

Today the Villa San Michele is owned by the Swedish government's Axel Munthe Foundation and since 2003 has been overseen by Peter Cottino. He is vice-consul of Sweden (and the only foreign consul on the island), and his area of responsibility is small, as it includes only Capri. "When Dr. Munthe's book came out in 1929, it was an immediate success," he says. "It has to do with Europe at that time and the period of the Great Depression. People needed to believe in the possibility of a dream: that is, if you want something badly enough, you will get it, provided you are willing to work and suffer for it."

Cottino believes that of the two towns, Anacapri is the healthier place to live, especially in winter. "Life goes on here," he says. "It is easier. Capri, on the other hand, is an open-air museum and can be bleak."

Opposite: View of Marina Grande from Villa San Michele.

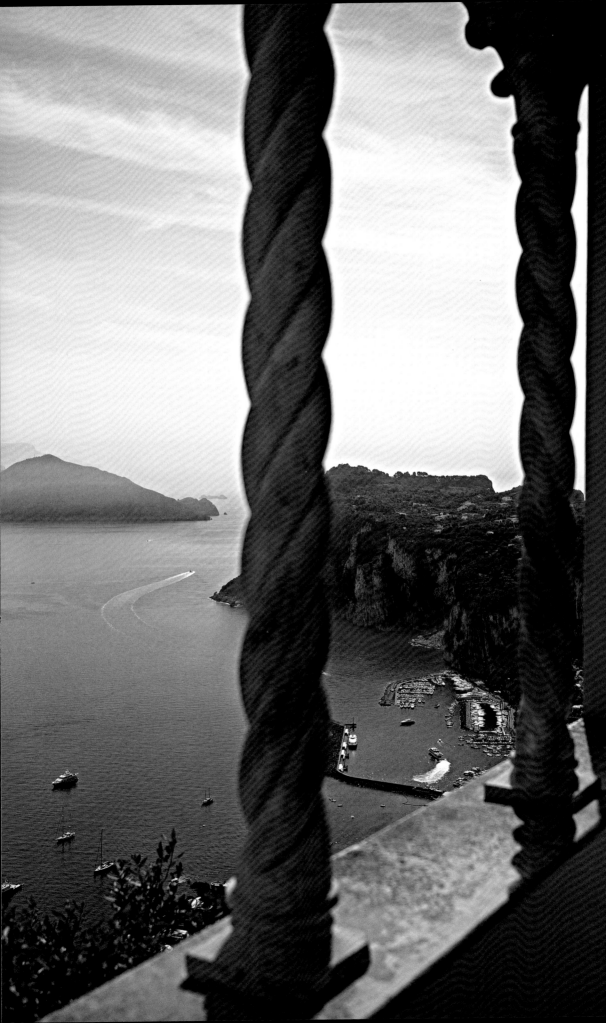

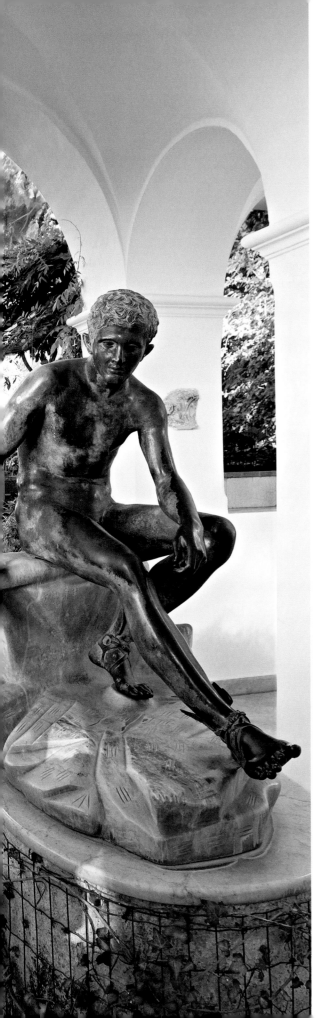

As for the Villa San Michele itself, it is anything but bleak, as is its story. Munthe, the son of a Swedish chemist, received his preparatory degree in medicine in his homeland but then emigrated south to France to complete his studies and then to practice, which he did with great success. But it was Anacapri that captured his heart. After he retired, Munthe lived in the village for forty or so years, although not always at the villa that he had so lovingly restored (he often rented it out and stayed elsewhere.) The house itself is rather small, but the loggia, with its curved arcades, columns, and statuary, is reason enough to visit. The Villa San Michele is said to be among the world's most beloved private residences open to the public (as much so as William Randolph Hearst's Castle, although a great deal more modest in scale). No wonder it attracts visitors by the thousands every year.

There are several good hotels in Anacapri, but the most deluxe, unquestionably, is the Capri Palace and Spa, owned by Antonio "Tonino" Cacace, the only son of the original owner. In 1961, Cacace's father, Mario, built a four-star hotel he called the Europa Palace. After Mario died in 1975 in a tragic boating accident that his son witnessed, Tonino Cacace abandoned his law career and set about creating a five-star property by embarking

Opposite: Roman and Greek statues grace the gallery of Villa San Michele.

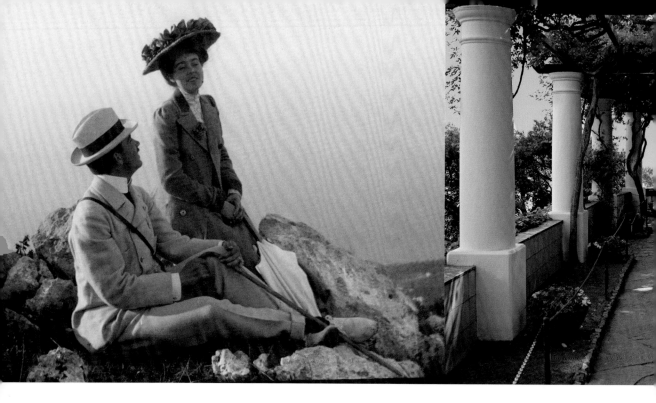

Left to right: Sweden's Crown Prince Gustaf with his fiancée, Margaret, at Anacapri, 1905; the columned walkway at Villa San Michele; above the villa is the Barbarossa Fortress, seen here in 1903.

on a massive renovation of the Europa, adding a top-of-the-line spa and changing the name to the Capri Palace. People on the island, including some of his friends, thought he was *matto*—crazy—but Cacace persevered, undaunted. His latest accomplishment has been to earn the hotel's restaurant, L'Olivo, two Michelin stars. Cacace, who has Tom Selleck-like looks and a missionary's zeal, is determined to see the village he was raised in get the recognition he believes it deserves. But that can happen only if there is a plan in place and someone to see that it is religiously adhered to. Tonino Cacace has appointed himself that person and is, in effect, Anacapri's visionary.

Though he was born on an island dedicated to hedonism, Cacace is something of a scholar and can speak at length about Capri's history. "Capri has been subjected to eight hundred years of invasions," he says, "by pirates, by Saracens and many others; so the islanders have developed the attitude that foreigners were always coming to Capri to *take*, not to give, whether it be women, jewels, or land. We used to be very suspicious of outsiders." The Anacapresi might regard even someone from Capri as a foreigner.

Cacace also thinks that, oddly, the islanders have what he calls a "bad relationship" with the sea. "They are afraid of it," he says. "The feeling is that you have to respect the sea, so it is better to stay away from it. This is why there is not a big fishing industry here. It is the tourists who brought the sea to us. The houses located close to the sea used to be valued less than the ones in the hills."

Cacace has a genuine understanding of Anacapri's evolution. Although the residents of Capri town have always been wealthy and successful and more accustomed to strangers than the Anacapresi,

Following Pages: The Etruscan sphinx at Villa San Michele.

the latter have recently experienced a boom in commercial development. The vicinity of the Capri Palace, and then the narrow path that goes to the Villa San Michele, is chockablock with souvenir shops, outdoor cafés, and stalls selling snacks, limoncello, local fragrances, pareos, cheap ceramics, and other items. The area is not, in fact, unlike the Marina Grande. But beyond this pleasantly chaotic place is a quiet little hamlet that few bother to explore. It is only lately that immensely affluent Italians, such as Diego Della Valle, owner of Tod's, Hogan, and Roger Vivier; and Luca di Montezemolo, who runs Fiat and Ferrari, have invested in homes in Anacapri when they could just as easily have bought villas in Capri.

Diego Della Valle lives in a historic house that once belonged to Axel Munthe. Before that it was a convent and retains its defense tower, and it is surrounded by a park. "The house is made from the island's typical resources," says its owner, "and, regardless of its sumptuousness, it makes you feel you are in a small and special refuge. "

Anacapri is where Della Valle, who has been going to Capri for years, finds solace. "I'm attracted by the sights, the light at dawn, and the long walks on the narrow roads," he says. "I can go out in the evening to Anema e Core, the nightclub in Capri, and return home to Anacapri as day breaks. Capri is where one can live with either a supreme intensity or a sense of reflection."

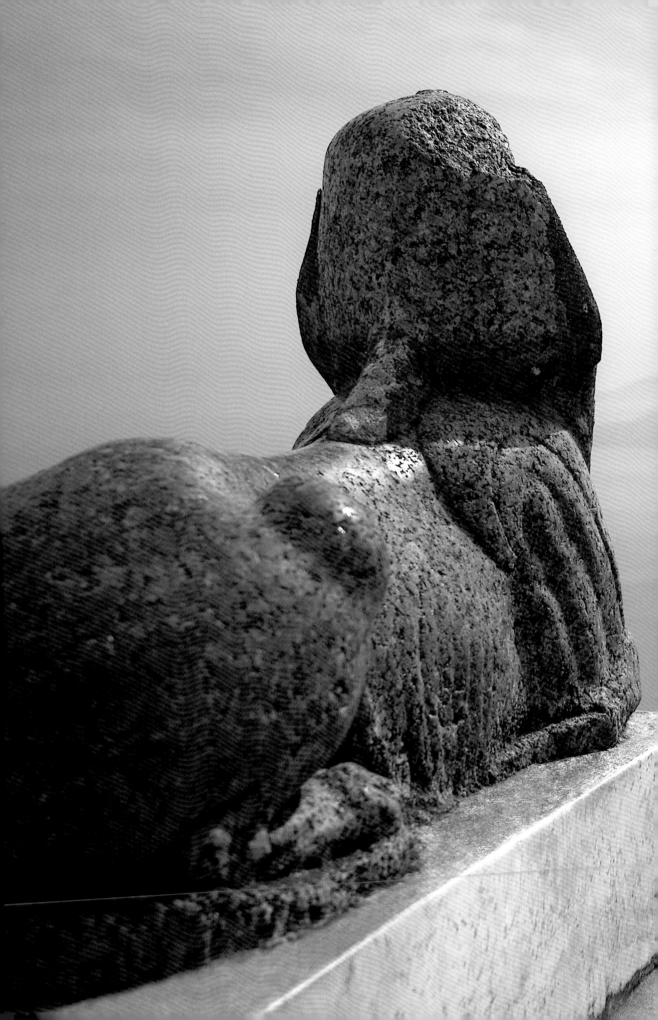

Restaurants

Here on this tiny island, everything seems to taste better. The cuisine consists mostly of the best raw vegetables and herbs—tomatoes, lemons, basil and thyme; *mozzarella di bufala*, usually served with *prosciutto*, or its richer cousin, the ambrosial *burrata*; freshly-snared fish; and, of course, pastas and pizzas. *Limoncello*, that potent after-dinner drink, a lemon-flavored eau de vie—a kind of grappa. The dessert of choice is chocolate-almond torte. Stick to the wines of Tuscany, Sicily, Piedmont and other regions of Italy. Here we see Marisa Berenson enjoying an afternoon glass of *vino bianco*.

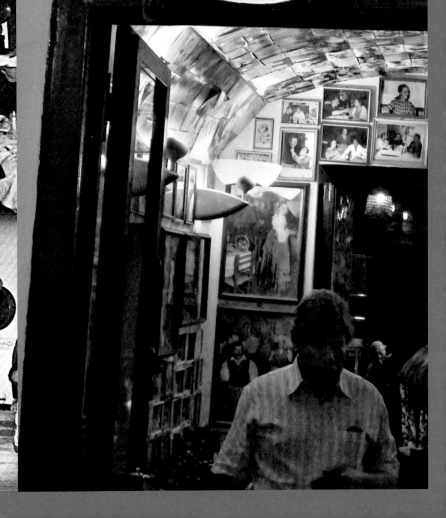

Exiles, Anarchists, Aesthetes, and Eccentrics

Capri always welcomes with joy anyone who comes to the island in search of self-expression, for such people usually end by causing as much enjoyment to others as they do to themselves. If they are eccentrics, so much the better; it has always been the Capri way to do as one pleases.
EDWIN CERIO, 1957

It has long been held that creative people work best in isolation, so what better location than an island such as Capri? Granted, there are distractions—the bustle of everyday workers sweeping the streets, making deliveries, shouting their *buon giornos* and *come stais* to their compadres; not to mention the tourists converging on the square in July and August. Still, Capri has enough blessedly quiet corners to allow the kind of concentration that serious writing requires. It's no wonder, then, that the island has periodically been a hangout for the literati. Writers, like artists, tend to prefer places where they can be with others of their kind: Think of Montmartre and the Left Bank cafés in Paris (Hemingway, Fitzgerald, Gertrude Stein, and Alice B. Toklas), the pubs of Dublin (Yeats, Joyce, O'Casey), and New York's legendary Round Table at the Algonquin (Benchley, Parker, Woollcott). In the case of Capri, an entire island put itself at the disposal of various writers, including Graham Greene, Mario Soldati, Norman Douglas, Curzio Malaparte, Compton Mackenzie, Pablo Neruda, Alberto Moravia, Rainer Maria Rilke, and Shirley Hazzard.

"For Graham, Capri was a hiatus," Hazzard writes in her memoir *Greene on Capri*. Greene's house, which was in Anacapri, was called Il Rosaio. He bought it in 1948 and owned it for more than forty years. There he not only felt he could write but also could be safely secluded with his mistress Catherine Walston while his wife and children were in England. He later took up with another woman, Yvonne Cloetta from Antibes. In all the time Greene had a house on Capri, he visited only in the spring and fall and never learned to speak Italian; he hung out in the Piazzetta at the Bar Tiberio and ate many of his meals at nearby Da Gemma, which no longer exists. And although Hazzard writes mostly of Graham Greene, through him she also reveals her own attachment to Capri and that of her husband, the writer Francis

Opposite: The terrace of Casa Malaparte, former home of the controversial political writer and novelist Curzio Malaparte. *Following Pages*: Casa Malaparte, dwarfed by the Faraglioni, but with a splendid view of the iconic rocks.

68

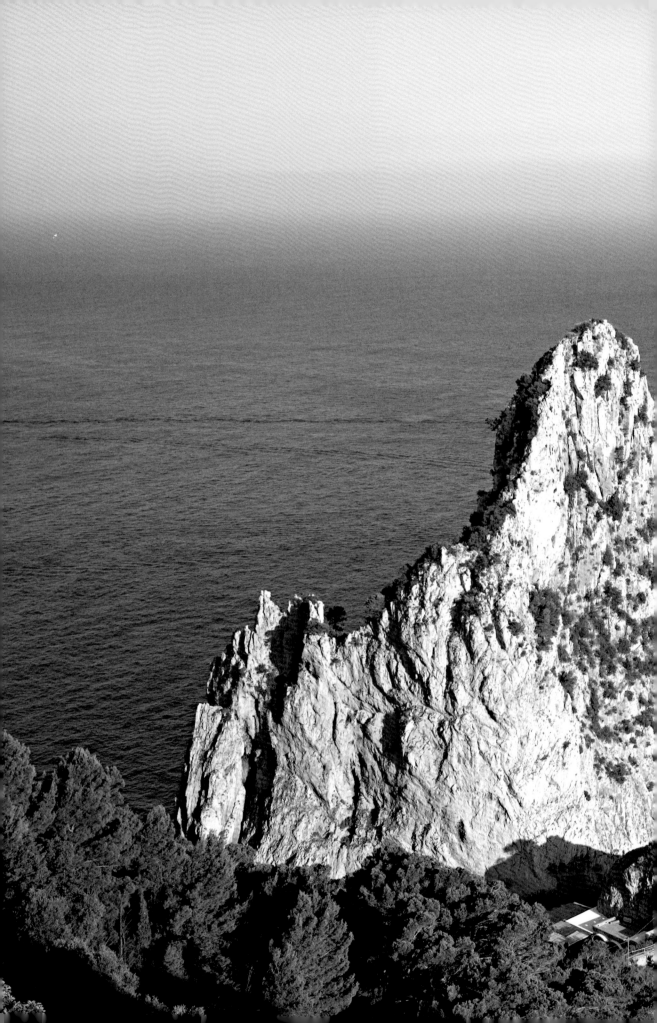

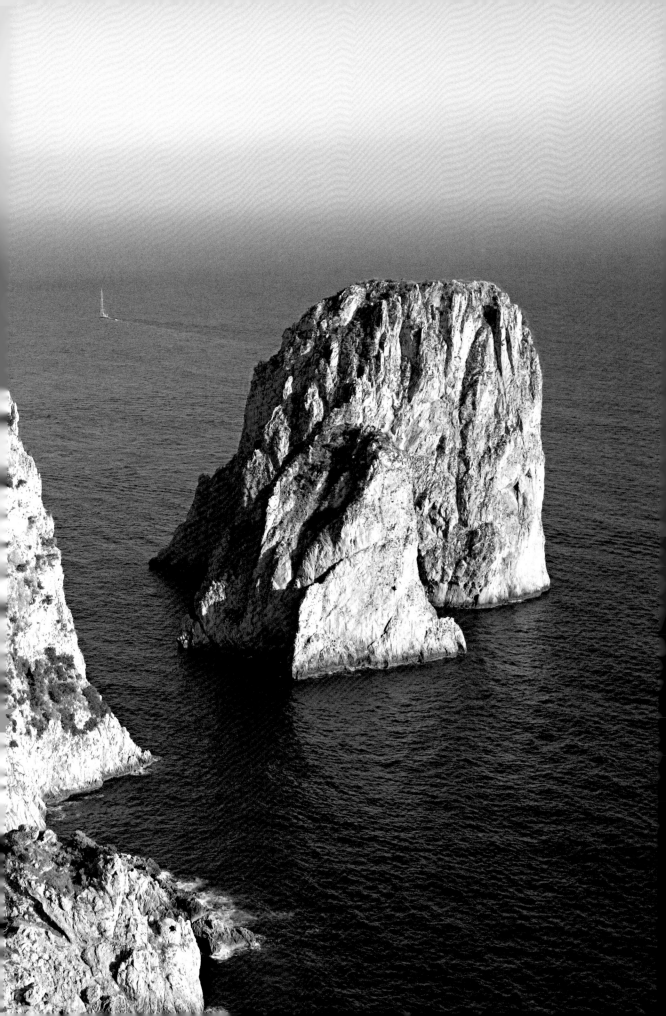

Nella Casa Arturo di via Tragara, Edwin Cerio
ha accolto, nell'inverno del 1952,
PABLO NERUDA
che nell'isola "dalla veste color giglio e amaranto"
ha composto "Las Uvas y el Viento"
e ha completato "Los Versos del Capitán"

En la Casa Arturo de via Tragara, Edwin Cerio
durante el invierno de 1952, acogió a
PABLO NERUDA
que en Capri la del "vestido de color amaranto y azucena"
escribió "Las Uvas y el Viento y Los Versos del Capitán"

In The Winter 1952, Edwin Cerio in his
"Casa Arturo" located in Tragara's street, had as his guest
PABLO NERUDA
Who composed on the island
"clothed in lily-white and reddish purple colours"
"Las Uvas y el Viento and Los Versos del Capitán"

12 Luglio 2004, centenario della nascita di Pablo Neruda
Città di Capri

Atelier del Centro ANTICO di PATRIZIA CUSTODE

Steegmuller. Indeed, the book is as much a journey to Capri through Hazzard's eyes as it is her recollection of her friendship with Greene.

Hazzard herself came to Capri for the first time in 1957, and her affection for the island never wavered: "For myself, I expect to arrive, throughout my lifetime, in this beloved place with the same joy."

It was thus for other writers as well. Norman Douglas was known as the sage of Capri. In his most famous novel, *South Wind*, he fictionalizes the island, calling it Nepenthe. But Douglas could also be dispassionate, even critical, concerning his favorite place. In *Footnote on Capri*, written in 1952, he rants, "At this moment Capri is in danger of developing into a second Hollywood and that, it seems, is precisely what it aspires to become. The island is too small to endure all these outrages without the loss of dignity—the pest of so-called musicians who deafen one's ears in every restaurant, roads blocked by lorries and cars, steamers and motorboats disgorging a rabble of flashy trippers at every hour of the day." Of course, by this time Douglas was an old man frustrated at the real possibility that his beloved island was somehow getting away from him.

Not every writer who spent time on Capri wrote about it. Graham Greene, for example, created parts of several novels there, none of them with Capri as a backdrop. He turned out a minimum of three hundred fifty words a day at Il Rosaio but often wrote more. Asked why he was so drawn to Capri, he couldn't give a clear answer. "It really isn't my kind of place," he even said once. For not being Greene's kind of place, Capri certainly brought out the best in him, and in other writers too.

Islands, by their very nature, have long been magnets for those who want to escape the rest of the world for any number of reasons and despite the inconveniences. This was certainly the case with Capri's earliest devotees, Augustus and Tiberius, who felt that they could run the Roman Empire from a distance yet exactly as they wanted. How they managed is a mystery. But when Rome was under Tiberius's rule, all eyes were on Capri. It wouldn't be the last time this island was the subject of such scrutiny.

Islands are also convenient places for banishment. Napoleon was exiled twice: first, in 1814, to the isle of Elba, from which he escaped. After briefly taking back his power, he was defeated at Waterloo and exiled a second time, to Saint Helena, off Angola.

No one as legendary as Napoleon was ever sent to Capri against his will. Indeed, it is hard to think of *anybody* who would have resisted being consigned to such

Opposite: In the winter of 1952, the Chilean poet Pablo Neruda stayed and composed at the home of the prominent Caprese, Edwin Cerio. *Following Pages:* Cover of *Capri–Ein Kleines Welttheater Im Mittelmeer* (*L'Ora di Capri* in Italian) by Edwin Cerio. Printed in Germany in 1954 by Verlag Georg D.W. Callwey München, Curzio Malaparte takes a break for lunch at a seaside restaurant.

EDWIN CERIO

CAPRI

EIN KLEINES WELTTHEATER IM MITTELMEER

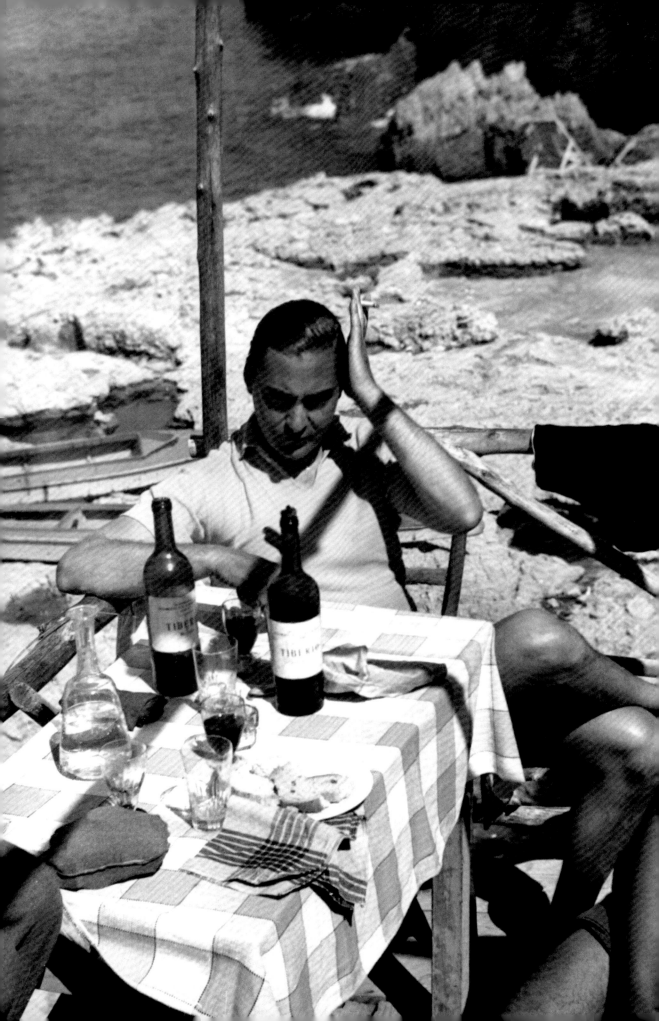

a paradise. Throughout its history, Capri has attracted its share of refugees longing for an out-of-the-way place where they could regroup, contemplate, create, and perhaps even plan for the future—sometimes the future of an entire nation. It is said that the Russian writer Maxim Gorky, along with Lenin and other dissidents, concocted the Bolshevik revolution of 1917 while on Capri. One imagines them huddled at a small table in the Piazzetta, conspiring over their espressos. Whether precisely true or not, it's a provocative picture.

What is true is that in the early 1900s, the island attracted a number of Russian intellectuals who opposed the czar's rule. Among them was Gorky, who shared a house on Capri with his companion, an actress known as Andreyeva (her real name was Maria Fyodorovna). Other Russians, such as the author Ivan Bunin and the opera singer Feodor Chaliapin, were also in evidence. Why Capri? Probably because they felt accepted. Once one of them came and felt welcome, others followed, which is often the way it happens. And there are indeed accounts of meetings and discussions in various places on the island that apparently played a part in the overthrow of the Russian government. That such a

Writers and compatriots Alberto Moravia and Ennio Flaiano in the 1940s.

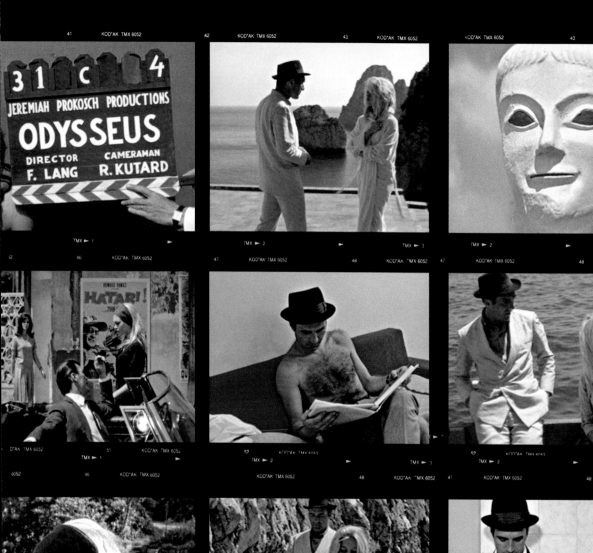

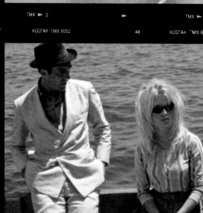
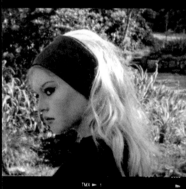

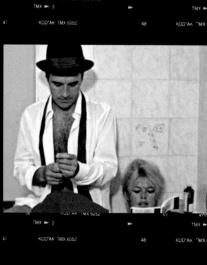

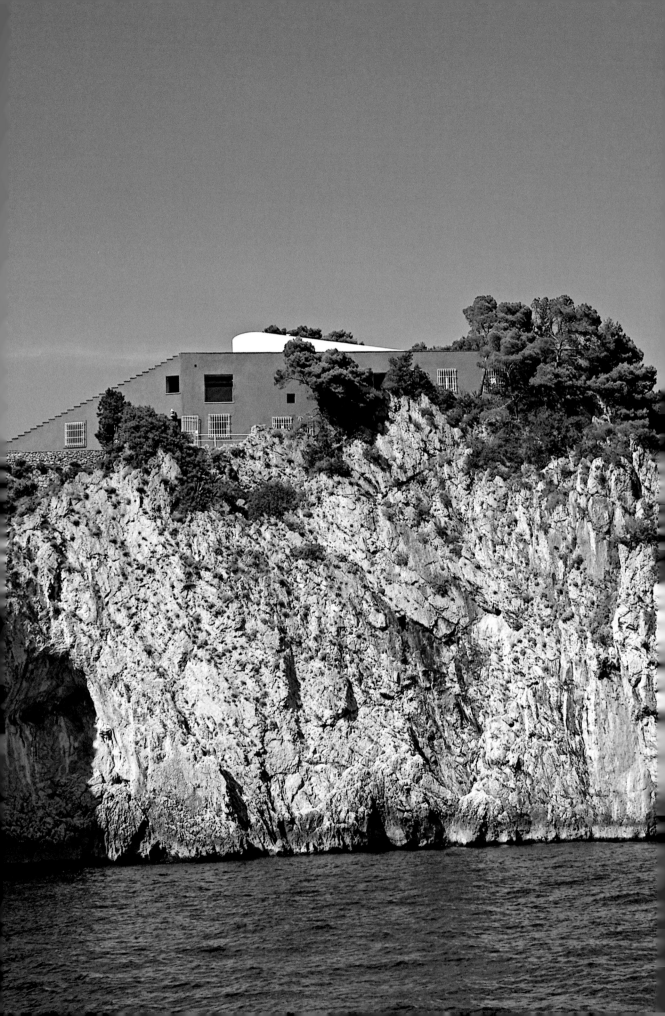

Edwin Cerio

THE MASQUE
OF CAPRI

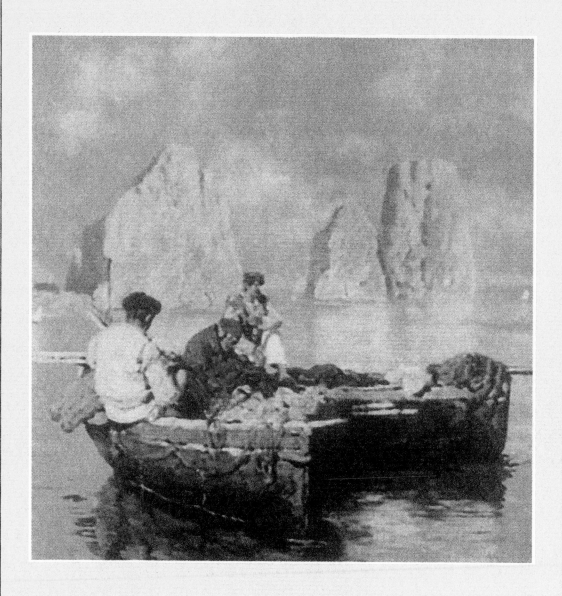

Edizioni La Conchiglia

Claudio Gargano

CAPRI PAGANA
URANISTI ED AMAZZONI
TRA OTTOCENTO E NOVECENTO

Edizioni La Conchiglia

Humbert Kesel

CAPRI
Biografia di un'isola

Edizioni La Conchiglia

Francesco Durante

IL RICHIAMO AZZURRO
STRIA LETTERARIA
DELL' ISOLA DI CAPRI

Edizioni La Conchiglia

Alf

TRA EPO
DIAR

a cura di

Edizioni L

Raffaele La Capria

CAPRI
E NON PIÙ
CAPRI

Edizioni La Conchiglia

Roger Peyrefitte

L'ESULE DI CAPRI

Edizioni La Conchiglia

Jean Bonin

UN RESPIRO LEGGERO
ED ALTRI RACCONTI

Edizioni La Conchiglia

Virgilio Lilli

UNA DONNA
S'ALLONTANA

Edizioni La Conchiglia

AT...
SE
E REMOTO

FUORI DALLE OMBRE
D.H. LAWRENCE E L'ITALIA DEL SUD
RACCONTI, LETTERE E VIAGGI DA
CAPRI, TAORMINA, RAVELLO
a cura di Luciana Rollo Bancale

Marcello Leone de Andreis

CAPRI 1943
C'ERA UNA VOLTA
LA GUERRA

Isabella Quarantotti De Filippo

IN MEZZO AL MARE
UN ISOLA C'È...

Edizioni La Conchiglia

plot may have been hatched on this seemingly politically inconsequential and tiny island does make one scratch one's head.

A likelier reason to seek out Capri has been to recuperate and lead a freer existence than one could in one's place of origin. Friedrich Alfred Krupp, grandson of the German steel and armaments magnate Friedrich Krupp and the richest man in Europe at the turn of the century, was subject to depression. He went to Capri because there he simply felt better—happier, more serene, and more appreciative of nature (not something the scion had much access to in Essen, the Krupp company's headquarters). The more he visited, the longer he stayed each time, leaving his family and friends behind and living a less demanding, less social life. He even became interested in the area's zoological aspects and built one of Capri's best roads, Via Krupp, which was recently reopened after a thirty-year hiatus. But, rumor had it, he also went on drunken outings to an island cave with some of the local young males. This rumor was Krupp's downfall, leading to his death in 1902 from either a heart condition or suicide. Or perhaps he was murdered. Welcome (again) to the dark side of Capri.

Krupp hasn't been the only German to discover Capri's delights. In the last years of the nineteenth century and early in the twentieth, there came an influx of German intellectuals whom the islanders unapologetically catered to—so much so that the most popular café by far was called Zum Kater Hiddigeigei. It was named after a cat that played on the roof of the adjacent Hotel Pagano (now the Hotel La Palma) and which in turn was named for the philosophical tomcat Hiddigeigei invented by the nineteenth-century German poet von Scheffel. Odder still, there is an entire book, published locally by Edizioni La Conchiglia, on Donna Lucia Morgano, the woman who presided over the café. The book compares Zum Kater to Rome's Caffé Greco (which still exists on the Via Condotti) and references a guidebook entry describing it as "an artistic salon, bazaar, currency exchange office, and beerhouse all rolled into one. And over all this chaos reigns supreme the ever florid Donna Lucia of the flaming eyes."

Interestingly, no really great foreign or Italian painters have settled on Capri. Picasso and Matisse opted for the south of France. Gauguin went to Tahiti to find stimulation. It was Venice that moved Turner to create his masterpieces. Most of the fine art inspired by Capri is relatively minor and of the traditional, untutored kind. Great writers, on the contrary, as well as a good many minor ones, have found the island sublimely suited to their craft and to their quirky dispositions—the quirkier the better.

Pages 78-79: Stills from the 1963 film *Contempt* (Le Mépris) directed by Jean-Luc Godard and starring Brigitte Bardot and Michel Piccoli. Casa Malaparte, where one of the movie's most memorable scenes takes place.
Previous Pages: The books of Edizione Conchiglia, Capri's preeminent publisher of local history.
Opposite: A deserted arcade, not so far from Capri's madding crowd.

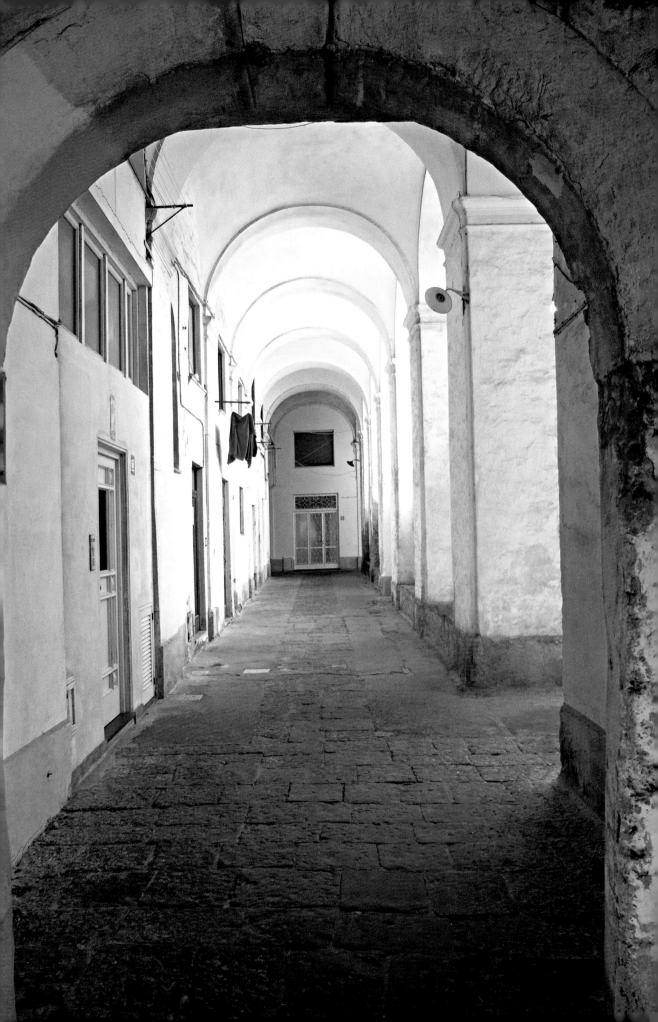

Capri has also been known as a haven for homosexuals, and is one to this day. In faraway, isolated places, it's easier to conduct one-self in ways that go against convention (and this was especially true during the Victorian period in Britain, when living a less restrained life was not accepted).

Among the gay men who came regularly to Capri, the most famous were the writers Norman Douglas, born in Scotland, and Englishman Compton Mackenzie, as well as the Swedish-French baron Jacques d'Adelswärd-Fersen, whose home, Villa Lysis, was built as an homage to Tiberius's Villa Jovis and was one of the island's most legendary dens of iniquity. In a 1984 *Vanity Fair* magazine essay called "Self-Love Among the Ruins," the travel writer Bruce Chatwin, himself at least bisexual, described Capri in the early part of the twentieth-century: "Capri was still a pagan paradise, where the wine was excellent, the sun always shone, and the boys and girls were pretty and available." It was the boys who most attracted d'Adelswärd-Fersen, and he made no secret of this. He dressed like a dandy and had an effete manner. He was also seriously addicted to opium and cocaine, which were ultimately his ruination. For years after his death, the baron's deserted villa was the haunted house on the hill wherein visitors could walk among tangled tree limbs, cobwebs, and undergrowth and pay tribute to the ghosts of debauchery. The Villa Lysis (also called the Villa Fersen) was somewhat tidied up and restored only recently, and it is still permeated by the intoxicating air of depravity—intoxicating for those who like that sort of thing, and apparently there are many who do).

Capri in the '30s.

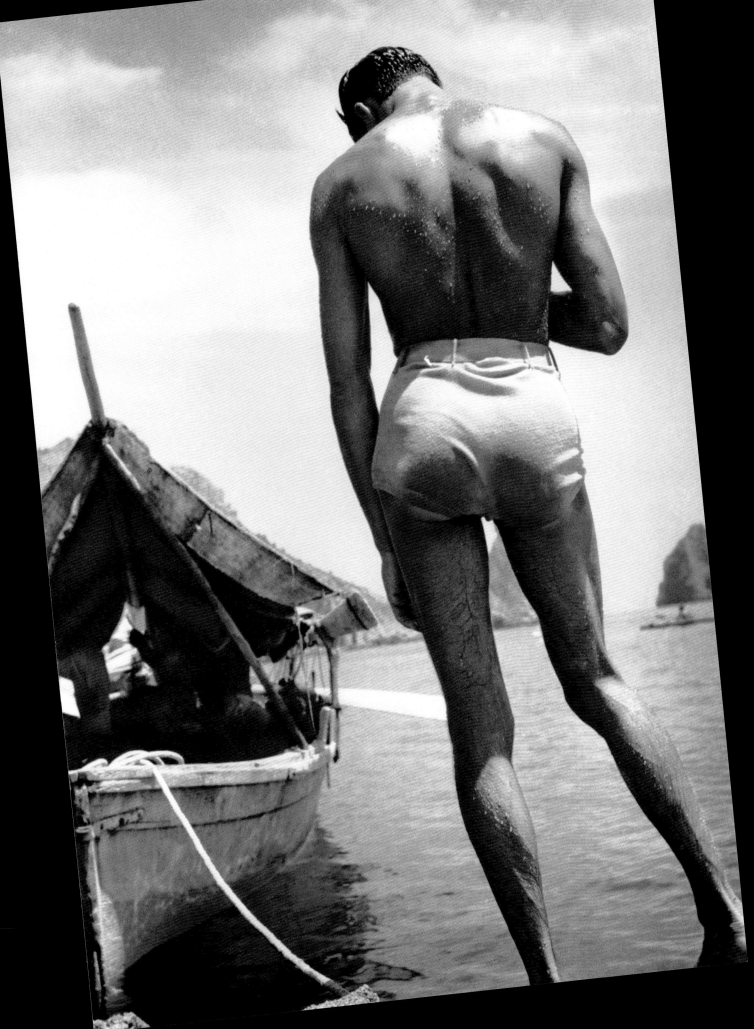

66My family has a home in Capri that is conveniently located just steps away from the Piazzetta, so that we always considered the Piccolo Bar an extension of our kitchen and living room.

Sometimes, I wonder what I am doing here in New York City. The 'real' me is an eight-year-old kid collecting 500 lire to buy a gelato at Scialapopolo's with my friends; that first kiss at fourteen on the Via Tragara; the long walks with my unforgettable nonna; the scars I still have on both knees from falling in the little alleys, when I was a toddler learning to walk; and so much more. Capri is my Utopia.99

AMEDEO SCOGNAMIGLIO

"Capri is so authentic. It attracts a very international and glamorous crowd of people in search of the fabulous. I find it that way every time I am there. Whether I am shopping for Capri's famous handmade sandals, enjoying the linguine alle vongole at Da Luigi or dancing on the tables at Anema e Core."

COLIN COWIE

"Capri is one big rock. Jump off the boat and you're swimming in clear water. There is no danger of sharks. I am forty-six now and have been coming here for thirty-eight years. When I was eight years old, I didn't realize how beautiful Capri was. I didn't appreciate any of the ancient aspects of the island. When I turned sixteen, I finally began to see the light—the Capri light."

AMERIGO LIGUORI

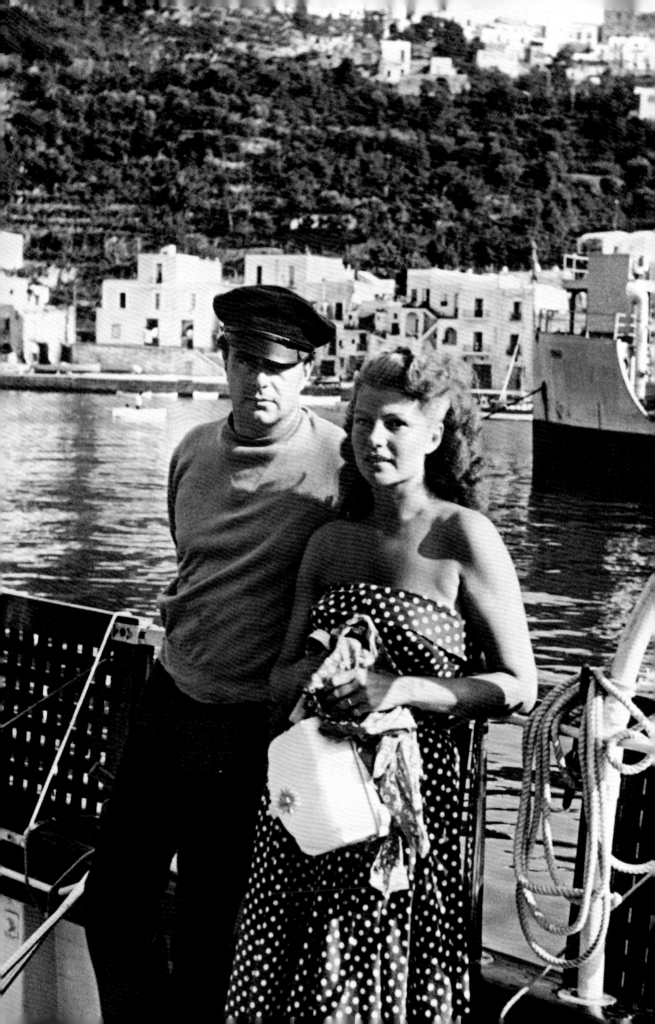

Golden Days

We'd dance all night, get up late the next day, and have lunch on the motoscafi (motorboats). Everybody knew everybody. It was what used to be called 'a happening' and really was quite a moment in time.
MARISA BERENSON

In the 1950s, the mid- to late 1960s, and the 1970s, Capri was again the island of choice, this time for celebrities. Whereas the writers Graham Greene and Norman Douglas and others had gone to the island to hide, movie stars and members of international society—such as Ingrid Bergman and Roberto Rossellini (during their scandalous affair); Rita Hayworth; Grace Kelly; Sophia Loren; Audrey Hepburn and Mel Ferrer; and later on, Brigitte Bardot, Jackie Onassis, and the designer Valentino—went there to be the center of attention. Their presence caused a stir: not quite a volcanic eruption; more like a tremble. But true to form, the Capresi did not bother them, which is not to say that they didn't take notice.

Because a number of movies were made on or near Capri, film crews and lead actors spent weeks there and often developed an attachment to the place that lasted for years afterward. The 1960 movie *It Started in Naples* (*La Baia di Napoli*) was filmed almost entirely on Capri and starred Clark Gable and Sophia Loren. In one scene, an irritated Gable, as an uptight American attorney, flings open the shutters of his hotel room window and growls to no one in particular in the noisy crowd, "How are people supposed to sleep on this island?" One of the café waiters looks up and answers sweetly, "Together."

Adriana di Fiore, who owns La Parisienne, the oldest boutique on Capri, has this recollection of Gable: "During the making of the film, Clark Gable was coming to the Piazzetta every day. He bought and paid for some clothes. After they were altered, I sent them to the Quisisana. But by that time he had already left for America. Later, he returned to Capri and stopped by La Parisienne. I said, 'So nice to see you back' and immediately fetched his purchases. He was so happy, but not just because what he had bought was still there. He was happy because after all this time, everything still fit him!"

Opposite: Rita Hayworth and Aly Khan in Marina Grande, 1950. *Following Pages:* Transport magnate Richard Bollinger on holiday, September 1989.

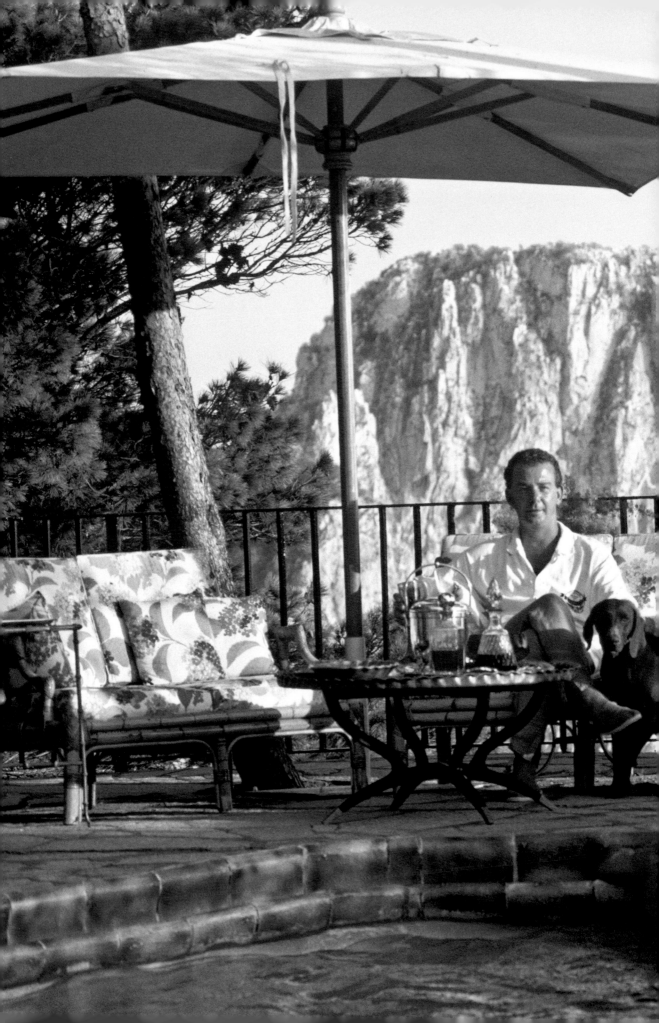

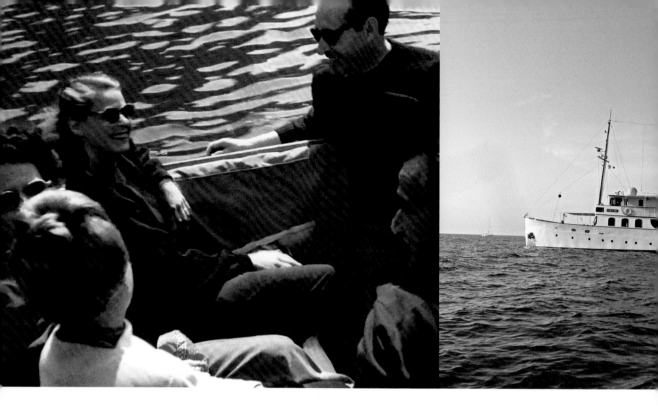

Left: Actress Ingrid Bergman and director Roberto Rossellini, 1949; *Right:* Sir Winston Churchill with opera diva Maria Callas on board the Christina, Aristotle Onassis's yacht, 1959.

La Parisienne is perhaps best known for the trousers known as Capri pants, which became a favorite of Jacqueline Bouvier Kennedy Onassis. "She was married to Ari at the time," says Adriana. "She would come in," adds Francesca, her daughter, "and as a courtesy, we would close the doors to other customers and let her shop in peace. She would buy at least six pairs whenever she stopped by, one for each house. Always in white." The same pants are still available, ready-made or custom-tailored, at La Parisienne, which celebrated its fiftieth anniversary in 2006.

When the Florentine designer and aristocrat Emilio Pucci opened his first boutique in 1950, it was on Capri. His vivid prints in hot pink, electric orange, lime green, and bright blue suited Capri perfectly, and Pucci understood this immediately. It wasn't long before the name Pucci and Capri were almost synonymous. A Pucci store still stands—this one on the Via Camerelle—as if to say "As long as Pucci is here, Capri style will prevail."

Marisa Berenson, actress, model, granddaughter of designer Elsa Schiaparelli, and a fixture on the fashion scene both in America and in Europe, recalls the 1970s on Capri: "I used to go there a lot because of the fashion show called Mare Moda," she says, "which was amazing. I remember being dressed in designers like Ossie Clark. I hung out with George and Alana Hamilton—they were still together then—and Diane von Furstenberg. We all stayed at the Quisisana, because that was the place to be. It was one big party.

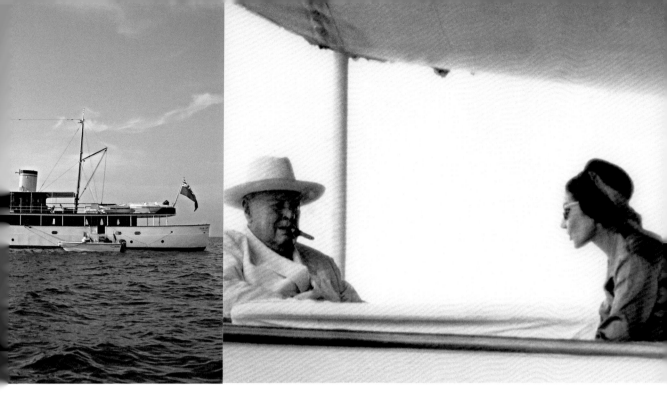

Following Pages: Sunbathers crowd the beach of Marina Piccola, 1970; Capri style: sexy and adorned.

"Every evening on Capri was so glamorous in the late '60s and early '70s," continues Marisa. "I dressed very bohemian back then and wore loads of accessories. My arms were covered with so many bangle bracelets, I don't know how I was able to move. Once, just back from a trip to India, I wore a turban with a big jewel in the middle of it.

"We all wore Capri pants made of Thai silk and sported those jeweled sandals so famous in Capri. When we went sunbathing, we donned wide-brimmed hats and the tiniest bikinis."

Fashion designer Oscar de la Renta went to Capri to receive an award—the Tiberio d'Oro—at Mare Moda and has this recollection of the experience: "It was 1967 or 1968. I was with my first wife, Françoise, and the American film director and photographer Jerry Schatzberg, with whom we were friends. He was living at the time with Faye Dunaway, who was doing a film in Rome with Marcello Mastroianni. The three of us went to meet Faye when she arrived on the hydrofoil. I said to Françoise, 'She's in love with Mastroianni.'" It turned out to be true. Dunaway and Schatzberg broke up on the world's most romantic island.

Pilar Crespi Robert has her own recollections of that era. Her parents, Rudi and Consuela Crespi, were the unofficial hosts of Capri then and strongly connected to the fashion world. It was Rudi's idea to create Mare Moda. "I was sixteen at the time," Crespi recounts, "and because my parents were very protective, I wasn't allowed to take part in the festivities. I also went with them to Capri when I was younger, about twelve. I was an avid

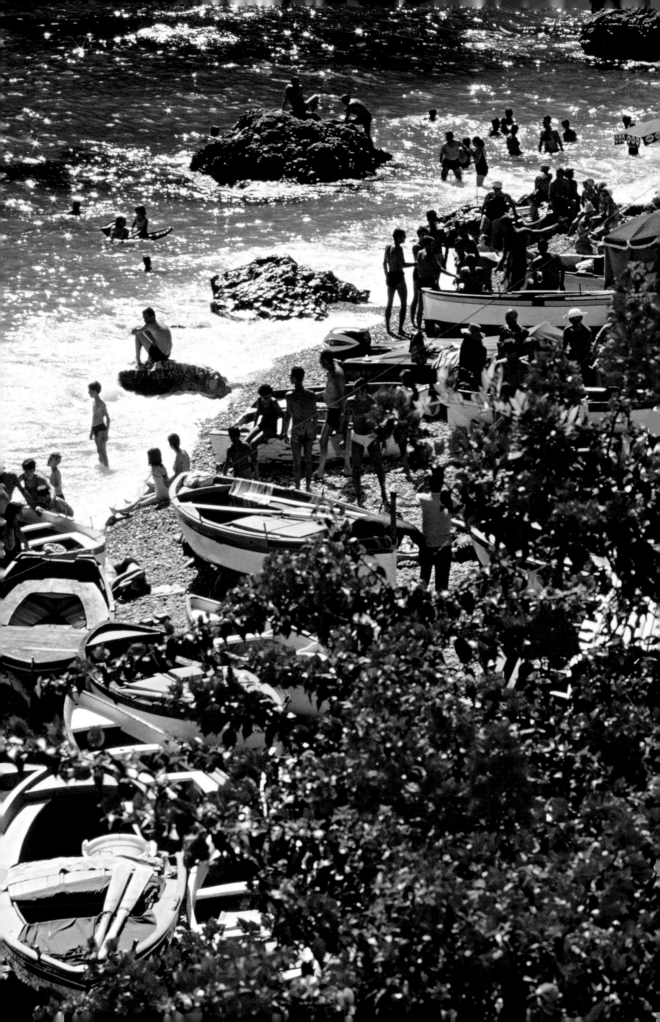

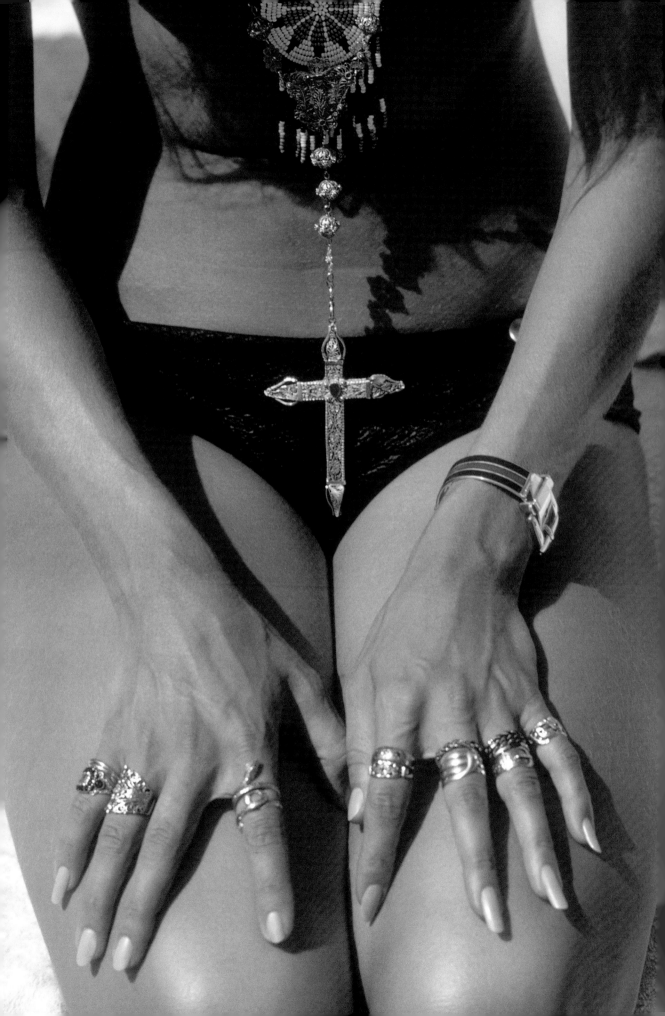

swimmer—I still am—and would swim from the beach at La Fontelina to the Marina Piccola. The water was beautiful.

"There were very few foreigners then, although the Piazzetta was still full. There were no cruise ships, either. It was a calmer life. I remember all the wonderful caprese boutiques with their happy fabrics.

"I had a sense of Capri being so unique at that time. We had a house on Ischia, and my parents would take me to Capri and visit their friends. When my father was organizing Mare Moda, he kept a diary and wrote of people coming to Capri, like Givenchy, Gianfranco Ferré, Missoni, Pucci, and Livio di Simone, a Caprese designer who was then the heart and soul of Capri.

"Mona Williams von Bismarck, one of the world's most beautiful women, would always give a dinner at her glorious villa the night before the official opening of Mare Moda. The purpose of the show was to revitalize Capri, which had experienced a small decline in the mid-sixties: Perhaps there were other, newer places in Italy that came into being, like the Costa Smeralda and Porto Cervo in Sardinia. The festivities took place over a weekend and lasted only a few years."

House on the way to Punta Tragara.

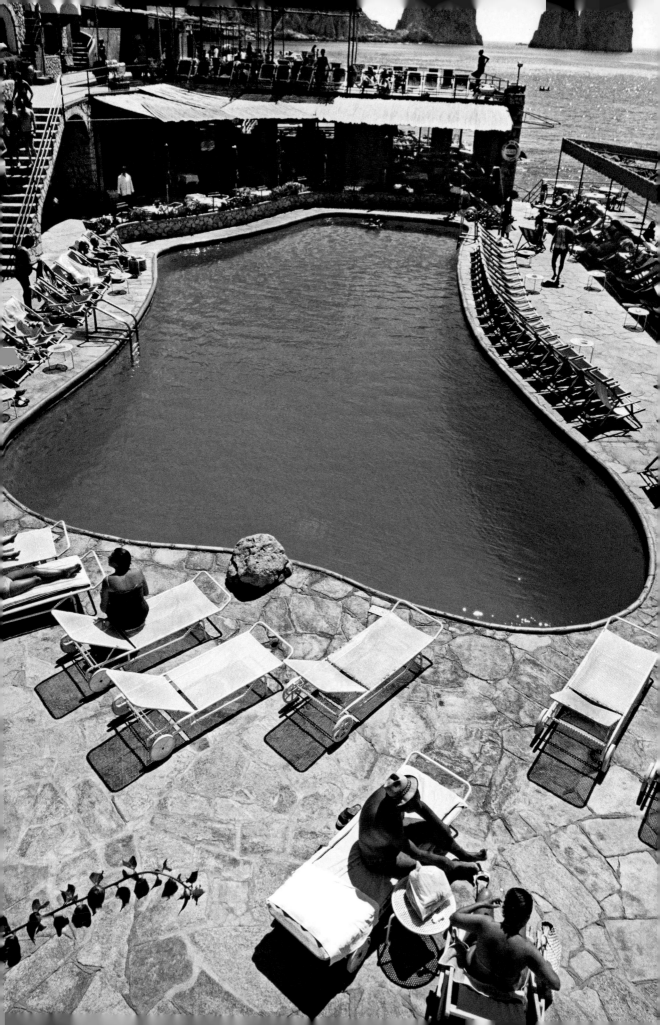

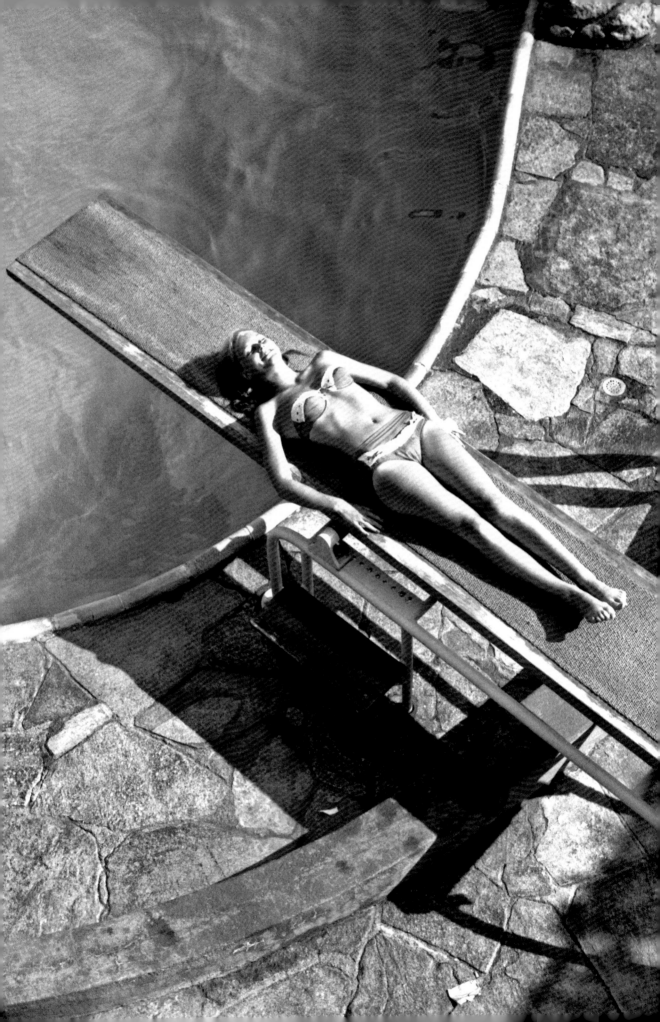

Giancarlo Giammetti, the couturier Valentino's longtime business partner and, early on, his lover, first went to Capri at the beginning of the 1960s. The couple bought a villa there. "I remember my first visit," Giammetti says, "going up the hill on the *funicolare* and thinking, 'One day I will have a little room here.' We got the house eight years later."

Now owned by Nicolino Morgano of the Scalinatella and Casa Morgano hotels, the villa is one of the most lavish on the island. Valentino and Giammetti hosted many a glamorous dinner party there. "Yes," says Giammetti, "we entertained a lot. There were so many interesting people, especially foreigners visiting: Onassis on the *Christina*, Charles Revson on the *Ultima*. These were huge boats for the time, full of great guests like Callas and Churchill, Jackie Onassis and her sister, Lee Radziwill. They loved to be asked over for dinner, and the house, with its big gardens and terraces, was perfect. I remember once when Jackie visited us, we had to stay there for four hours because the electric gate was broken by a *paparazzo*, and we were stuck inside." Evidently, the paparazzi were beating down the doors of celebrities' homes and invading their privacy even back then.

Capri style continues to flourish today. Perhaps the Capri look is where the phrase "casual elegance," now a cliché, comes from. Surely much of it can be attributed to the influence of Emilio Pucci and Jackie Kennedy Onassis—the in-and-out popularity of Capri pants, oversized sunglasses, and jewel-encrusted sandals and espadrilles. There is a way to put all the pieces together that makes up Capri style, and perhaps only the most innately stylish women can pull it off. Marisa Berenson can get away with having both her arms laden with bangles and not look silly. But the average woman should proceed with caution: A little Pucci goes a long way.

Previous Pages: La Canzone del Mare, Capri's most famous private beach club, in 1984; sun-worshipping on a diving board at Canzone del Mare, 1961. *Opposite:* Giancarlo Giammetti (left) and his partner, the couturier Valentino (far right), at a Mare Moda fashion event in 1968. *Following Pages:* Babe Paley and Truman Capote on deck, 1968. *Pages 104-105:* Alana and George Hamilton take time to tan themselves during Mare Moda, 1968; Princess Maria Pia di Savoia and Prince Alessandro of Yugoslavia, 1955.

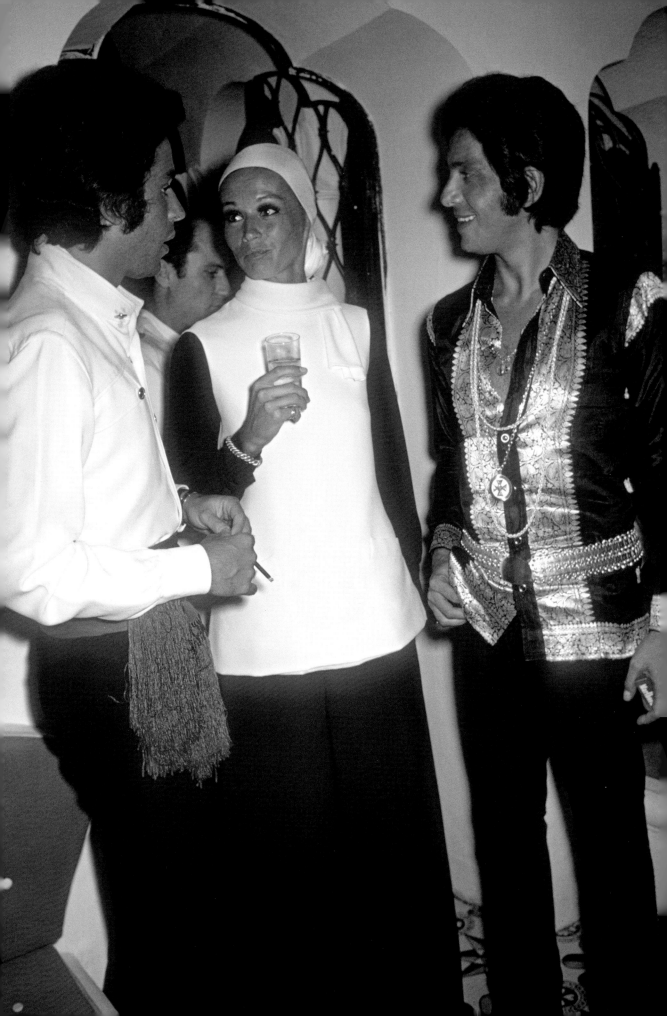

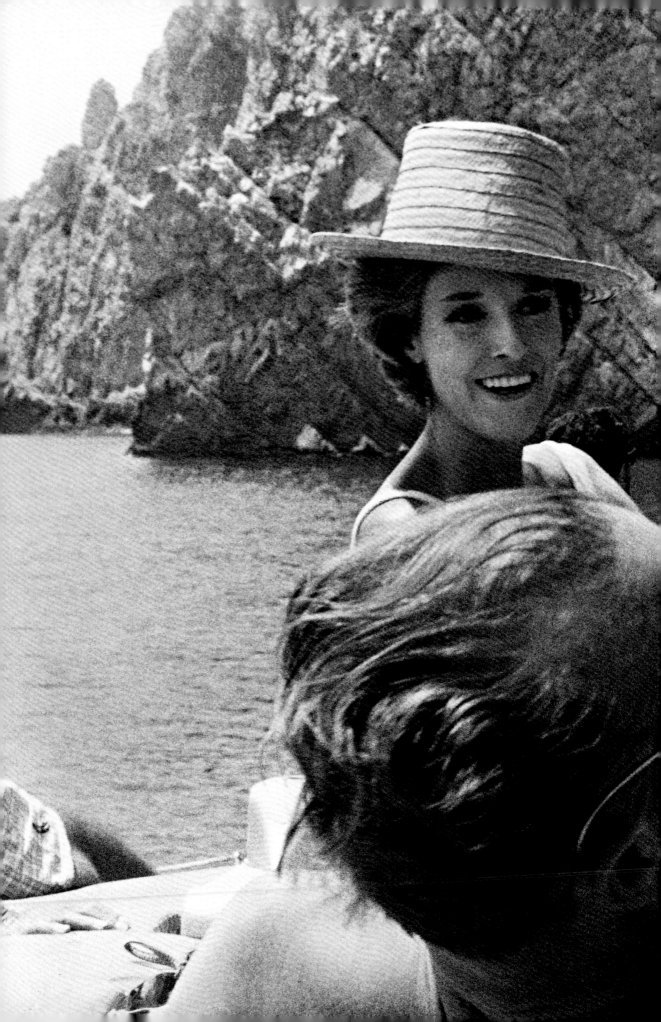

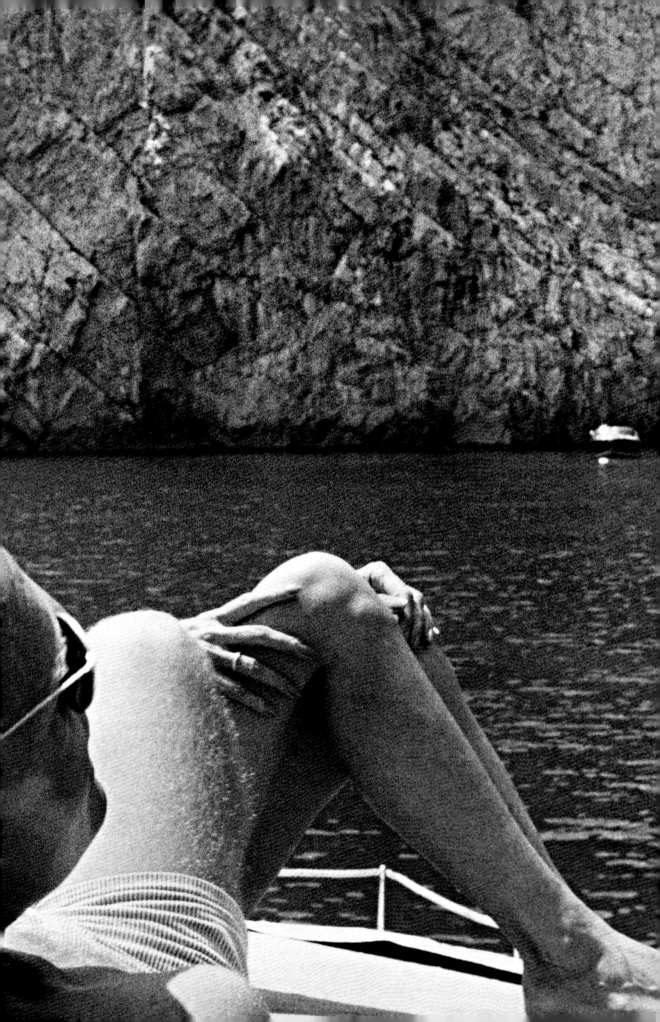

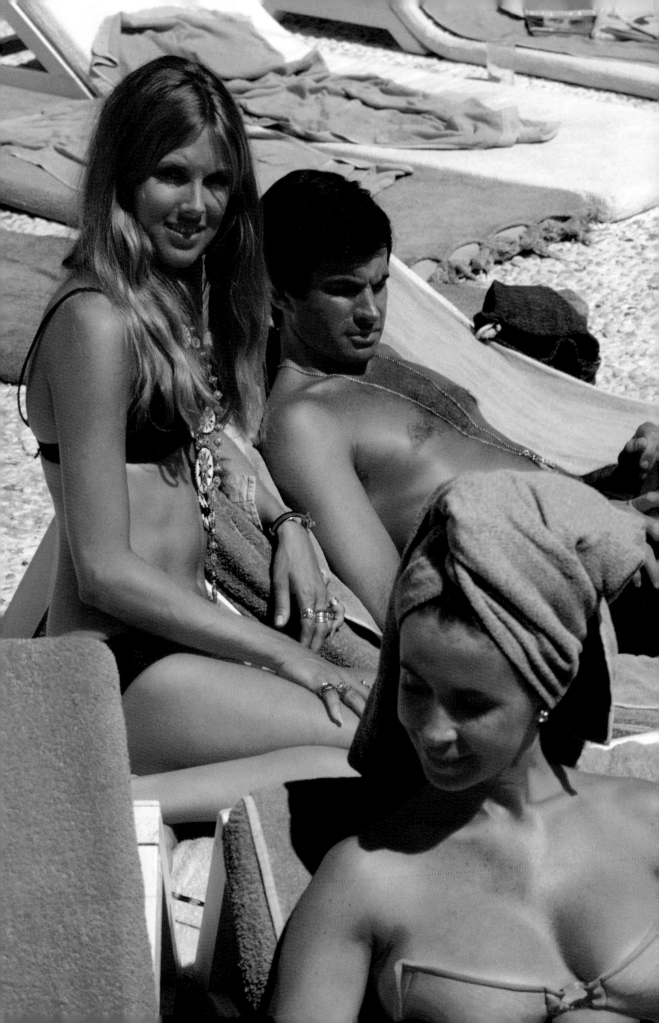

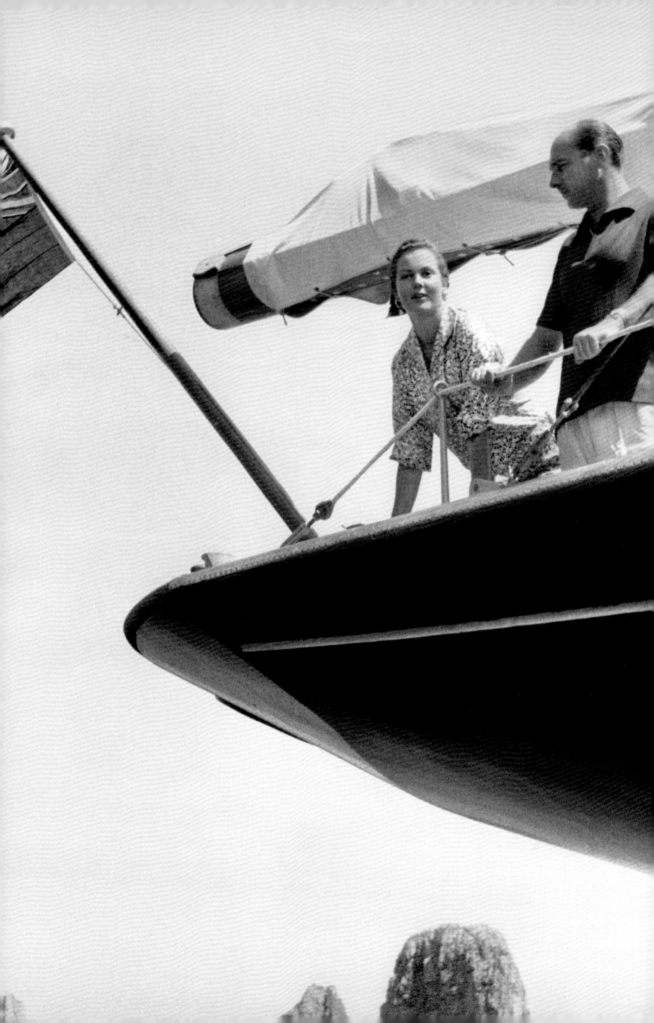

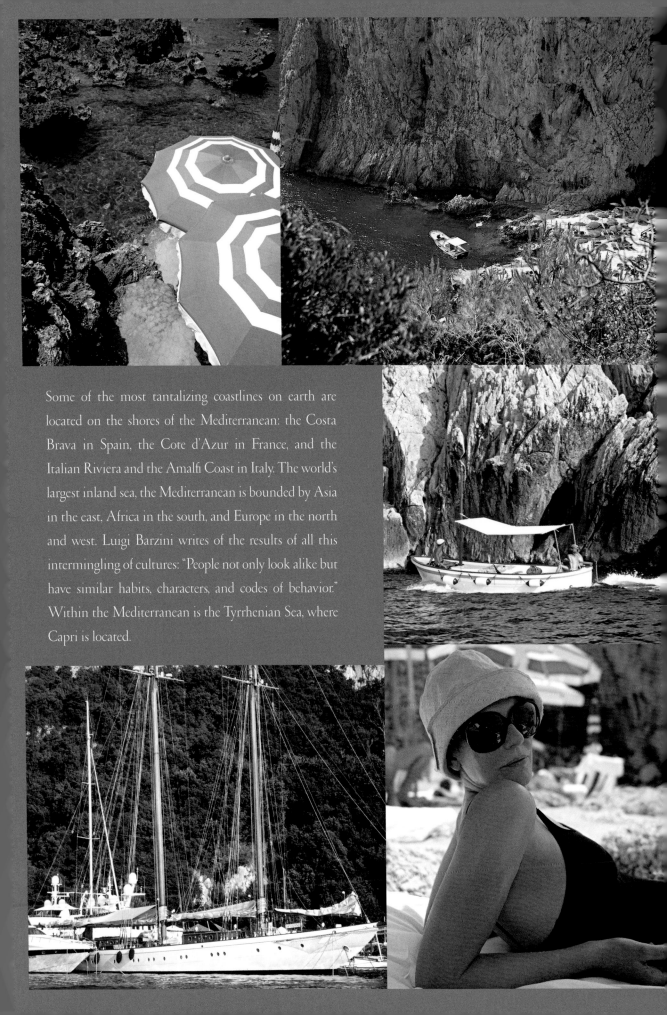

Some of the most tantalizing coastlines on earth are located on the shores of the Mediterranean: the Costa Brava in Spain, the Cote d'Azur in France, and the Italian Riviera and the Amalfi Coast in Italy. The world's largest inland sea, the Mediterranean is bounded by Asia in the east, Africa in the south, and Europe in the north and west. Luigi Barzini writes of the results of all this intermingling of cultures: "People not only look alike but have similar habits, characters, and codes of behavior." Within the Mediterranean is the Tyrrhenian Sea, where Capri is located.

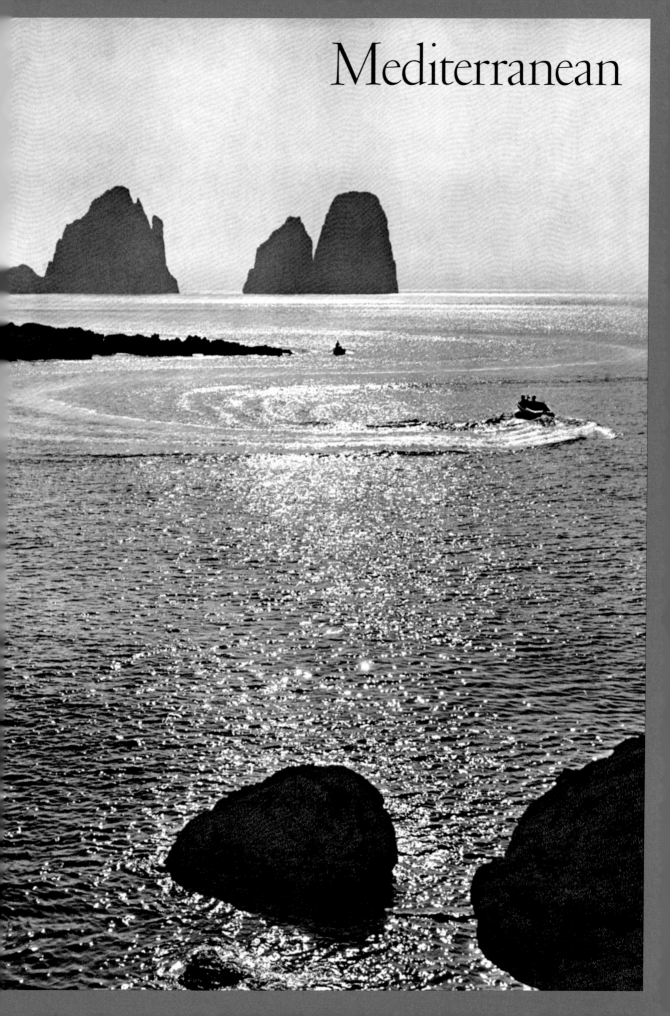

Mediterranean

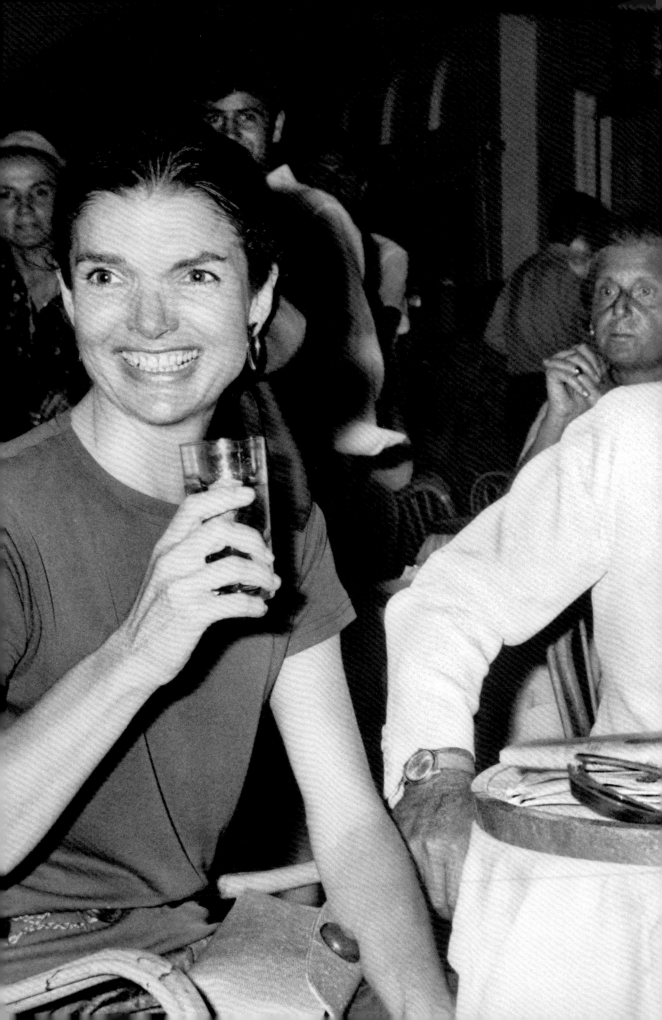

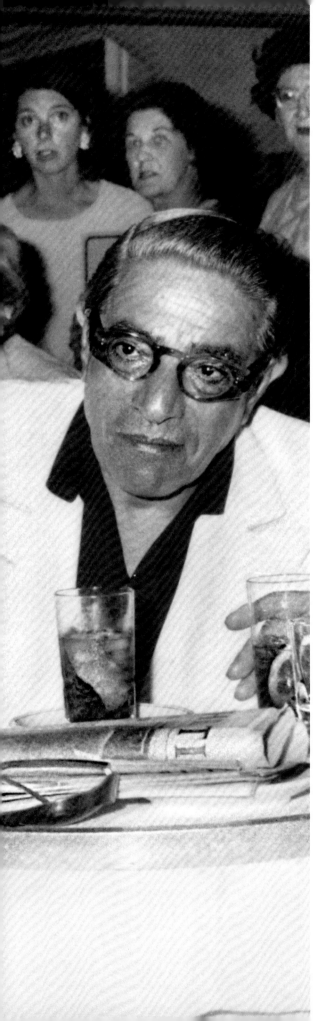

The Piazzetta

It was a pleasant rule. It ran to the effect that in the course of the forenoon all the inhabitants of Nepenthe, of whatever age, sex, or condition, should endeavor to find themselves in the market place or piazza—a charming square, surrounded on three sides by the principal buildings of the town and open, on the fourth, to a lovely prospect over land and sea. They were to meet on this spot; there to exchange gossip, make appointments for the evening and watch the arrival of newcomers to their island.

NORMAN DOUGLAS, 1929

In his 1929 novel *South Wind*, Norman Douglas depicted an idyllic island that he dubbed Nepenthe, a thinly veiled Capri. Anyone who read the book and had ever been to Capri recognized it instantly, especially if they noted the passage above, an accurate description of the island's main square.

In Italian culture, piazzas are those gathering places where everyday life is played out in public. The great ones are like vast drawing rooms—Piazza San Marco in Venice, Piazza del Popolo and Piazza Navona in Rome and, in Florence, Piazza della Repubblica. The typical piazza is usually a space of some dimension, sometimes with a fountain in the center,

Jacqueline Kennedy Onassis with her second husband, Greek shipping tycoon Artistotle Onassis, having a cool drink on the Piazzetta in 1969.

111

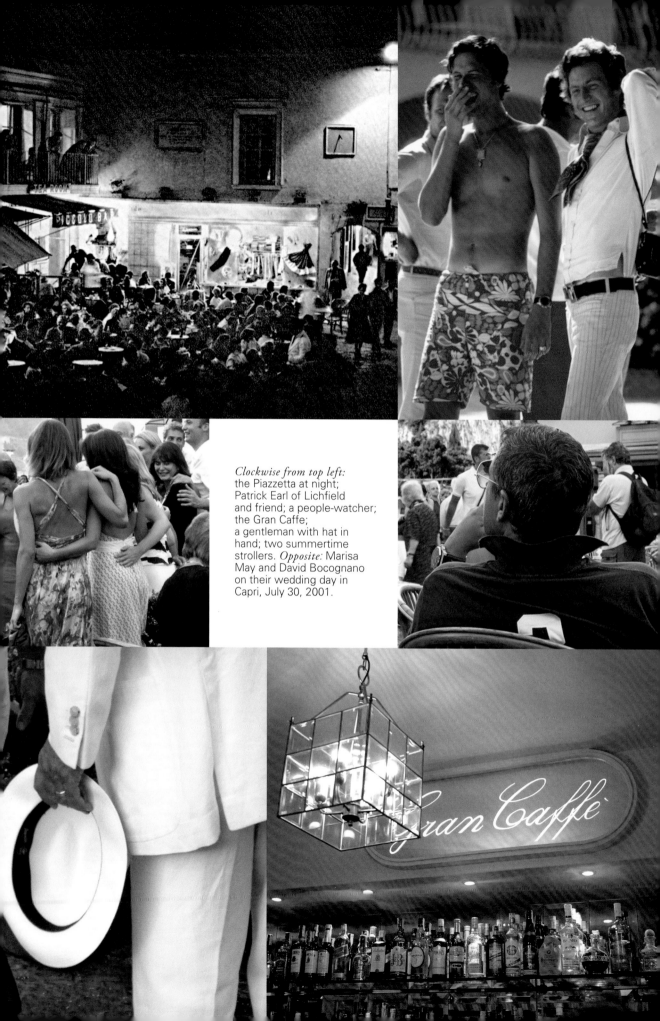

Clockwise from top left:
the Piazzetta at night;
Patrick Earl of Lichfield
and friend; a people-watcher;
the Gran Caffe;
a gentleman with hat in
hand; two summertime
strollers. *Opposite:* Marisa
May and David Bocognano
on their wedding day in
Capri, July 30, 2001.

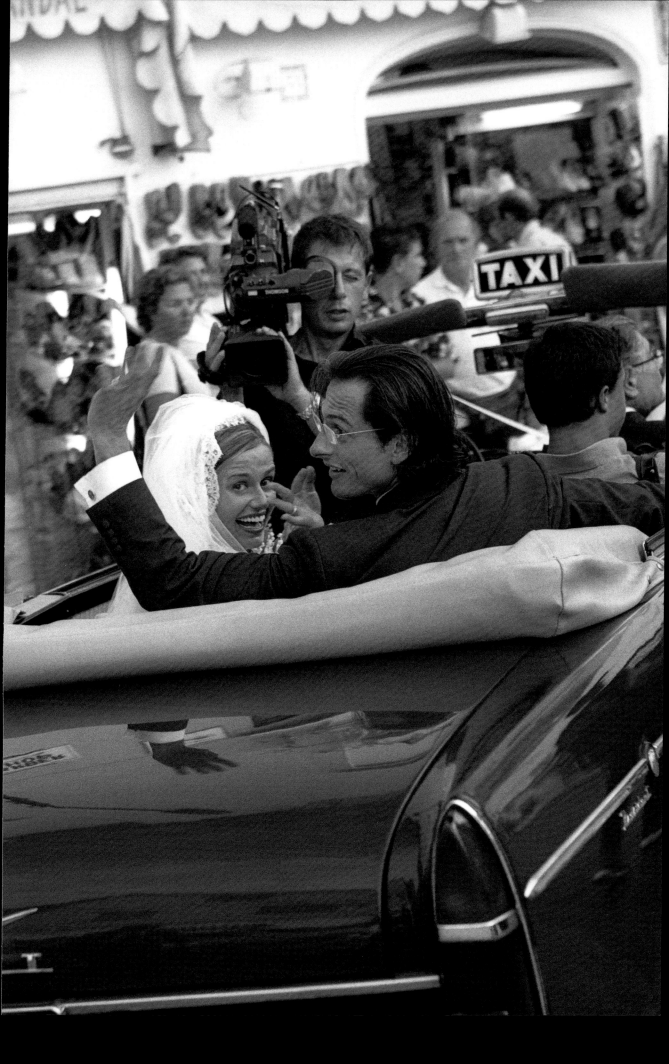

surrounded on the perimeter by cafés where habitues sit for endless periods of time nursing their *caffes, gelati* or *aperitivi*. They read the newspaper, they chatter, they squabble and, most often, they just look at other habitues and passersby and make silent judgments. In certain Italian towns and villages, the early evenings are reserved for a a lesiurely stroll through the square called *la passeggiatta*. It is a ritual (not as observed in these frenzied times as it used to be) that enables a certain display of one's best assets—a family's first baby, an expensive purchase like a fur coat or piece of jewelry, someone's latest conquest, or one's own beautiful body—for all to see.

In Capri, the square (and not all piazzas are perfectly square—some are rectangular, oval and so on) is small and almost always crowded, except in the dead of winter. So small is the area that it has come to be known as the Piazzetta ("little piazza"). Rather than being a grand salon in the European sense, the Piazzetta is more like a tiny parlor. The cafés—there are four—are so close that they they practically converge on one another, leaving little room for walking through it—but that doesn't seem to be a hindrance. It is still the best way to reach certain shops or streets, Moreover, it is the center of Capri and, as the cliché goes, a place to see and be seen. And on an island such as Capri, being where one can be noticed is of some consequence.

The Piazzetta, which most likely dates back to the time of Tiberius, was initially a market area, then a religious place graced by a Benedictine monastery. The cloister was replaced in 1687 by the cathedral of Santo Stefano. In the first half of the nineteenth century, the area became a public square, but it wasn't until 1938 that the first café, the Piccolo Bar, opened on the Piazzetta and that changed everything. Suddenly, a thoroughfare became a stopping place, especially for locals. Eventually, three other cafés followed and remain open for business to this day: in one corner is Bar Tiberio, a favorite of gays, and what was once the crypt of the church of Santo Stefano; the Gran Caffe, front and center and directly across from the Piccolo Bar, attracts an older, more established crowd; Bar Caso is next to the campanile, or bell tower.

The Piazzetta opens on to a larger open space which has a glorious view of the sea and the Sorrentine Peninsula and has access to the cable car that leads down to Marina Piccolo. In high season, there aren't too many moments in the course of a day when life in the Piazzetta is anything but aflutter with activity. Locals and regulars, however, will tell you their favorite time is in the early summer mornings when most of the island is still asleep. American restaurateur Michael McCarty and his artist wife, Kim, make it their ritual—seeing Capri wake up and spring into action. "There is no other town that runs the way Capri does We go to the Piazzetta every morning at seven

Opposite: Capri's clock tower is accurate, but no matter: no one pays attention to the time.
Following Pages: A rare and quiet moment in the Piazzetta, 1984.

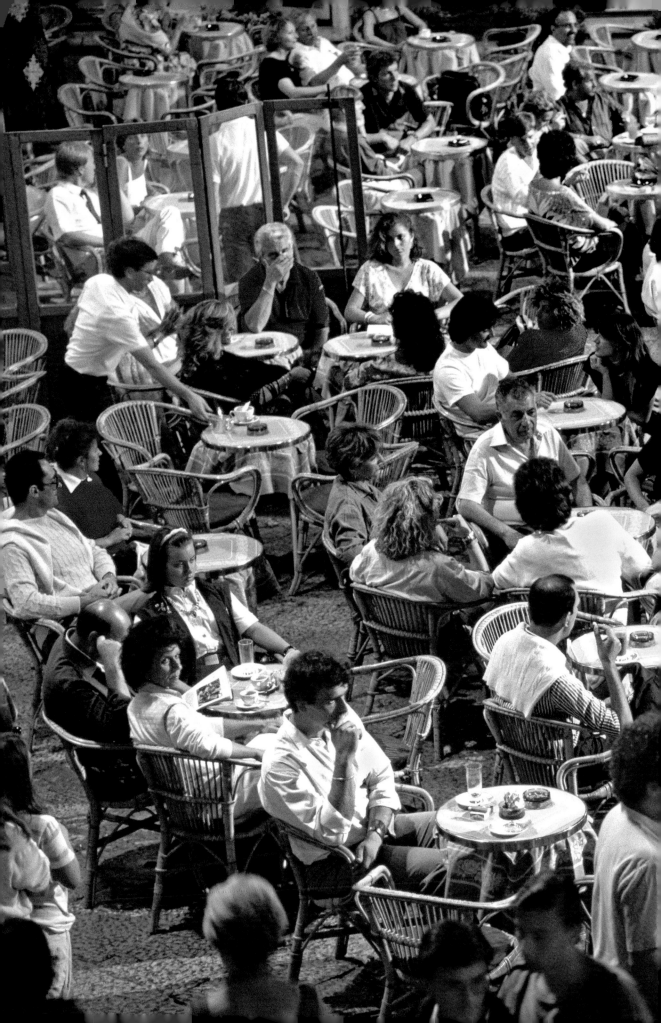

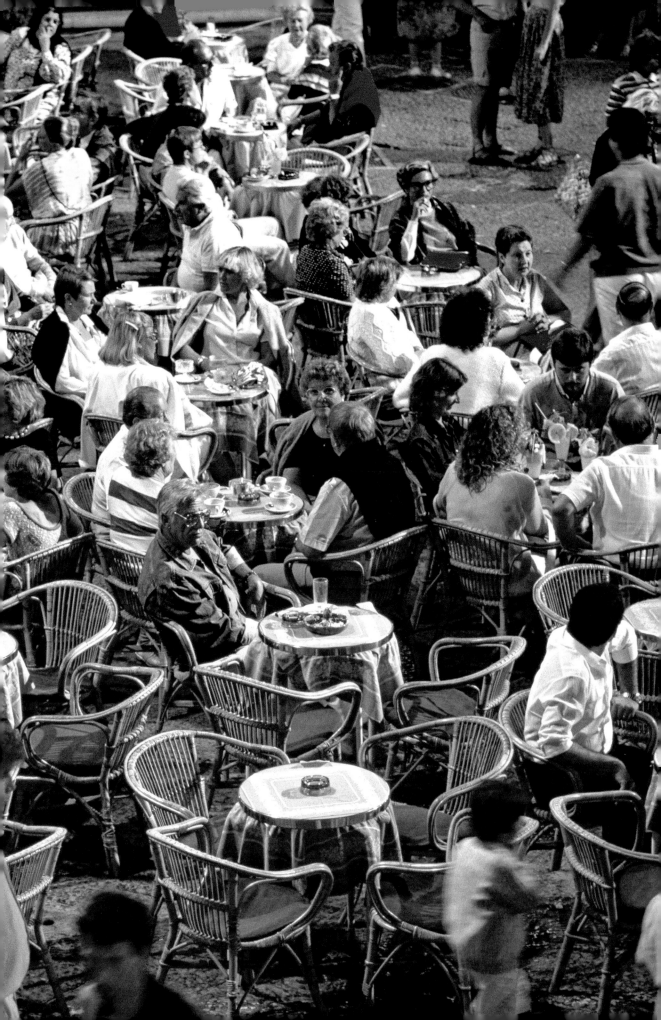

a.m. It's out of a scene from *The Truman Show*. We go to the bar across from the Gran Caffe, have our cafe doppio and watch Capri unfold. That's when you can truly appreciate how industrious and well run the island is."

By around eleven, sometimes sooner, the madding crowd of tourists descends on Capri signalling that it is time for all others to scatter elsewhere—to the beach, on a boat, back to their hotels or homes. It is only late in the afternoon, well after lunch and once the crowds have vanished, that the Piazzetta once again becomes a pleasant and relaxed (relatively speaking) place to be.

The McCartys not only start their day at the Piazzetta, they end it there too: "At about eight p.m., we go to the terrace of the Quisana, order our Negronis, have dinner and then afterwards, go to the Piazzetta for a nightcap." As for any other time, follow McCarty's rule: "Give the square over to the daytrippers and never go there during the day."

It's a familiar refrain.

An engraving of café society on Capri, 1892.

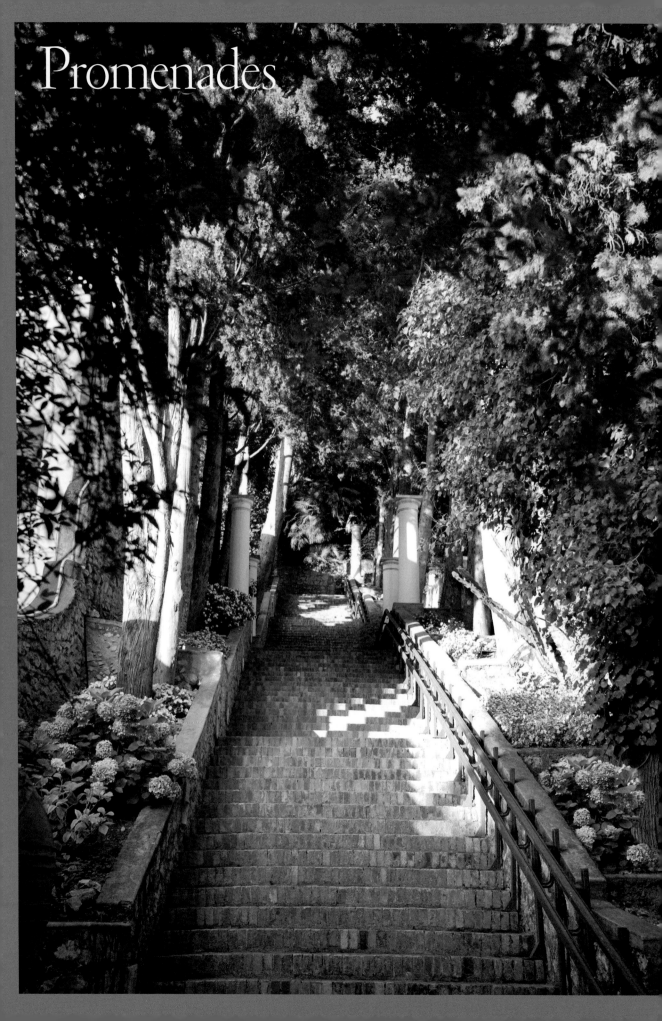

Promenades

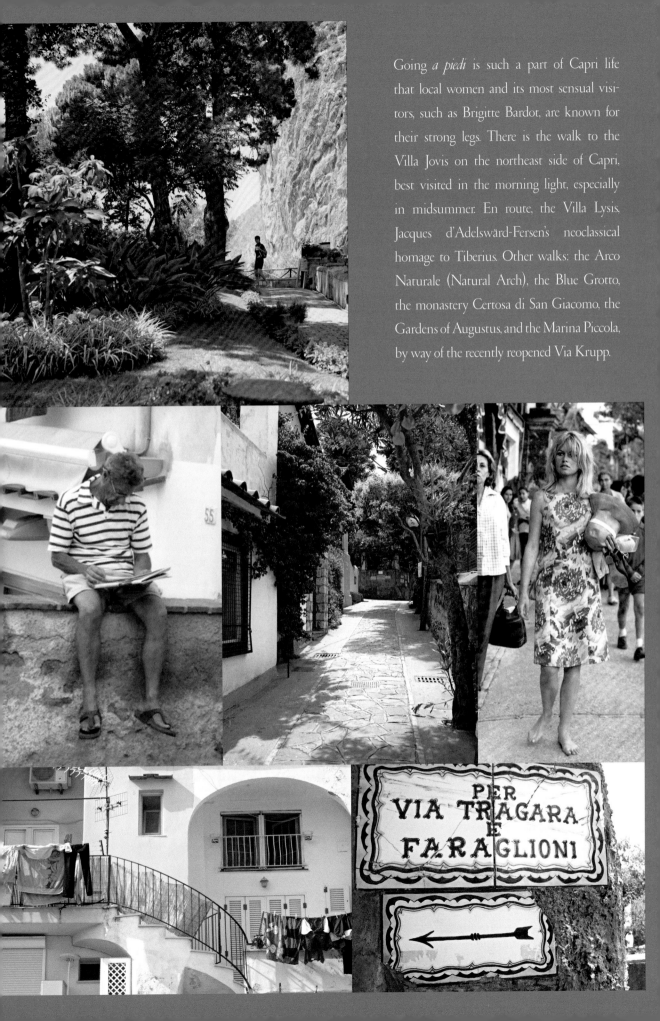

Going *a piedi* is such a part of Capri life that local women and its most sensual visitors, such as Brigitte Bardot, are known for their strong legs. There is the walk to the Villa Jovis on the northeast side of Capri, best visited in the morning light, especially in midsummer. En route, the Villa Lysis, Jacques d'Adelswärd-Fersen's neoclassical homage to Tiberius. Other walks: the Arco Naturale (Natural Arch), the Blue Grotto, the monastery Certosa di San Giacomo, the Gardens of Augustus, and the Marina Piccola, by way of the recently reopened Via Krupp.

PER
VIA TRAGARA
E
FARAGLIONI

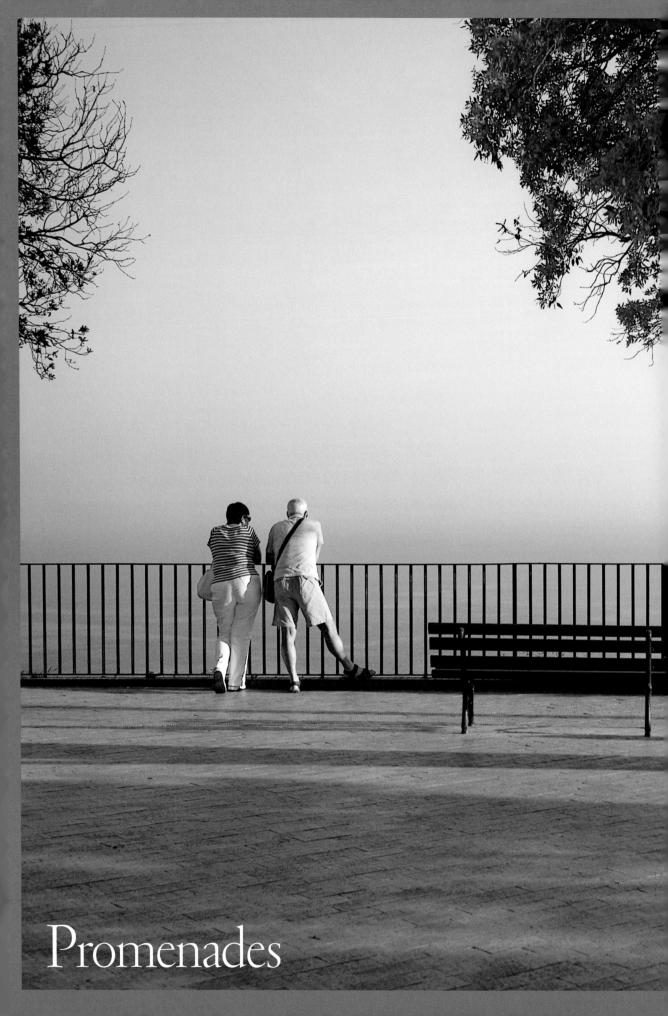

Promenades

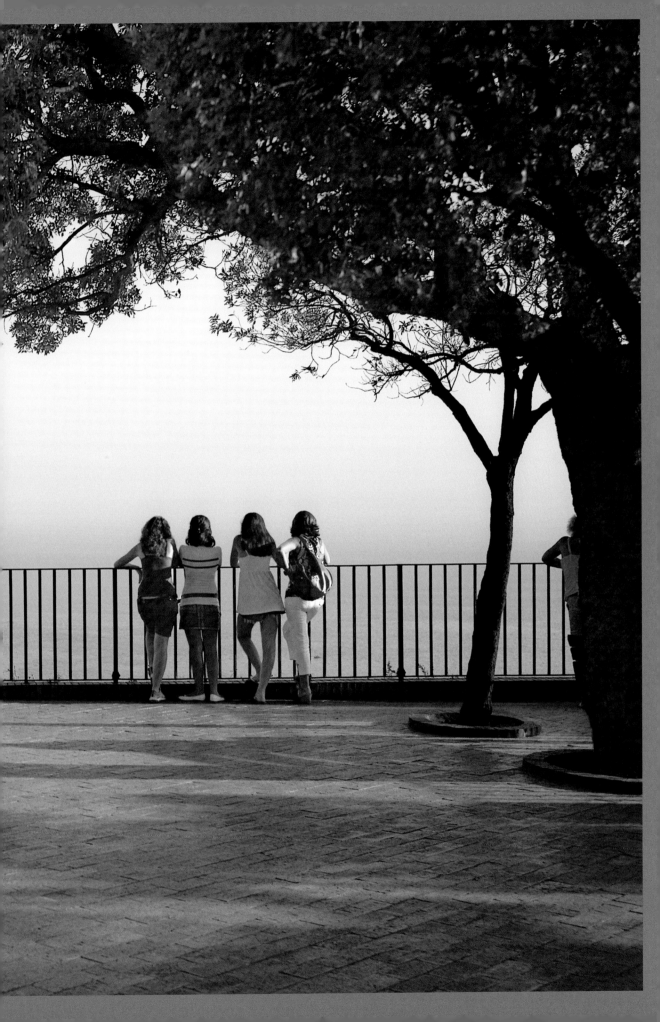

Fabled Hotels

When a visitor arrives there, he feels that the natives—sons of the sun, masters of their own republic and fabulous lords—did him a remarkable favour just because they give him hospitality.
SIBILLA ALERAMO

The root of *ospitalità*, the Italian word for hospitality, is *ospite*, or "guest." In Capri, having a guest is a matter not taken lightly. It is an art practiced *con delicatezza*, with delicacy. When a tourist arrives on Capri, the rules the locals follow are similar to those they practice in their homes: Be cordial and respectful, but not overly familiar. Be kind, but not so solicitous that the guest overstays his welcome. Bend over backward to be accommodating, but not to the point of doing a somersault, *un salto mortale* (after all, you could hurt yourself).

Hospitality, Capri style, begins with the Grand Hotel Quisisana. It wasn't the first lodging on the island—that was La Palma—but it is certainly the most famous. The Quisisana's terrace faces the Via Camerelle, Capri's chicest shopping street; after the Piazzetta, the terrace is the best place from which a guest can have a full and fascinating view of every passerby. Fashion designer Michael Kors, who for years has stayed at the Quisisana, where he's whiled away many a cocktail hour, compares its terrace to the coveted front row at a fashion show: Sit there long enough and you will eventually see everyone worth seeing. In an article in *Town & Country* in 1975, the ritual was described as follows: "If you want to follow the schedule, it is most important that you stop by the terrace of the Hotel Quisisana for a cocktail at 9:30 p m. According to a particular protocol probably started back in the heyday of the Stork Club, you have to sit in the far right-hand corner to be considered *in*."

Established in 1845, the Quisisana has had several incarnations. Its name literally means "here one heals" (*qui si sana*), and while the luxurious spa was added only a few years ago, from the start the hotel, whose efficient and cordial staff has always treated guests like family, was deemed the best place on the island to unwind. Not everyone, however, was warmly welcomed: when Oscar Wilde visited Capri in the late 1890s, after serving his prison sentence in England for homosexuality,

Pages 122-123: As people take their leisurely walks, they often pause to take in any of a number of extraordinary panoramas. *Opposite:* Great views are available almost everywhere, even from a hotel bathtub, such as this one at the Hotel Punta Tragara.

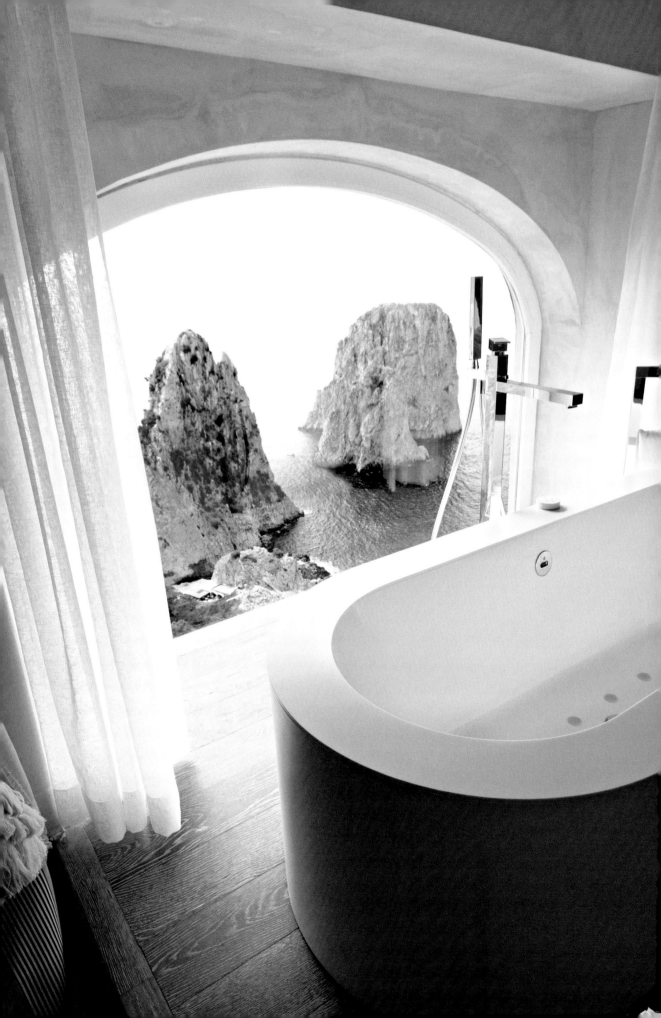

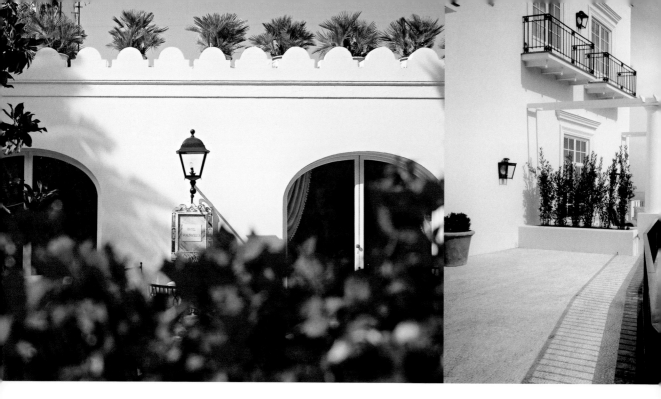

Left to Right: A trio of hotels: The Scalinatella; JK Place; the Gatto Bianco.

his appearance in the Quisisana's dining room caused such a stir that one British guest threatened to leave if he were allowed to remain. Hotel management politely asked Wilde to leave.

That episode confirms how much like a private club with an influential membership the Quisisana used to be. "To get into Capri society you must rent a villa or at least live at the Quisisana," the American journalist Herbert Kubly wrote in *Stranger in Italy*, published in 1956. The operative word here is "live"; it was not unusual for guests to stay for weeks at a time and return year after year, upon each departure making their reservations for the following season.

Despite its large size—it now has 148 rooms—the Quisisana is still run as a family business and always has been, although not always by the same family. And here is where the drama comes in. Two prominent Caprese clans, the Paganos and the Morganos, once fought each other for control of the hotel. The struggle apparently divided the locals and captured the attention of all Capri. In the end, the Morganos won and have been the Quisisana's patriarchs ever since, and have added two smaller properties, the Scalinatella and Casa Morgano, to their holdings. Peace has been restored.

The Scalinatella has its devotees—all of them grownups—but young families must go next door to the Casa Morgano. This is what made it so right for the McCarty family, that and its proximity to the shops and services. "Location, location, location," says Michael McCarty. He always goes with his wife, Kim, and their two children the first week of July,

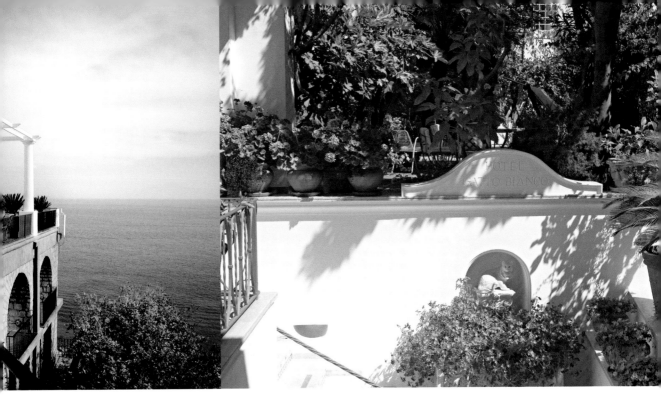

"when everybody on the island is in a good mood and hasn't been beaten up yet by tourists."

It's fair to say that though there are a good number of decent-to-fine hotels on Capri itself, the Morganos have the luxury end pretty well sewn up with their trio of properties. Gianfranco Morgano runs the Quisisana, while his brother Nicolino, the youngest son, takes care of the Scalinatella and the Morgano. "The Scalinatella was two very old houses with a lot of connecting steps," he explains, "and that is exactly what it is now. Our family bought it in 1981 and then in 1984 purchased Casa Morgano, which is similar to the Scalinatella but is the 'quiet twin.'"

For Nicky Morgano, Capri is "like one big hotel. Those who frequent our properties are at the top of their tier and terribly busy. When they come to us, they want to relax; they don't want to think. That's why the services are so important. It is our job to make our guests' lives easy. We don't have to be happy; *they* have to be happy.

"When people first come to stay with us," he says, "maybe it's for a week or ten days. Then when they are about to leave, they might say to themselves, 'It is not enough.' So the next year, they may come back for twelve days or more, some for weeks."

As for competition among the trio of hotels, Nicolino and Gianfranco hold that, as Nicolino says, "the guests of the Scalinatella don't want to go to the Quisisana, and the guests of the Quisisana don't want to stay at the Scalinatella."

The newest addition to the high-end-hotel scene is JK Place, beautifully done though

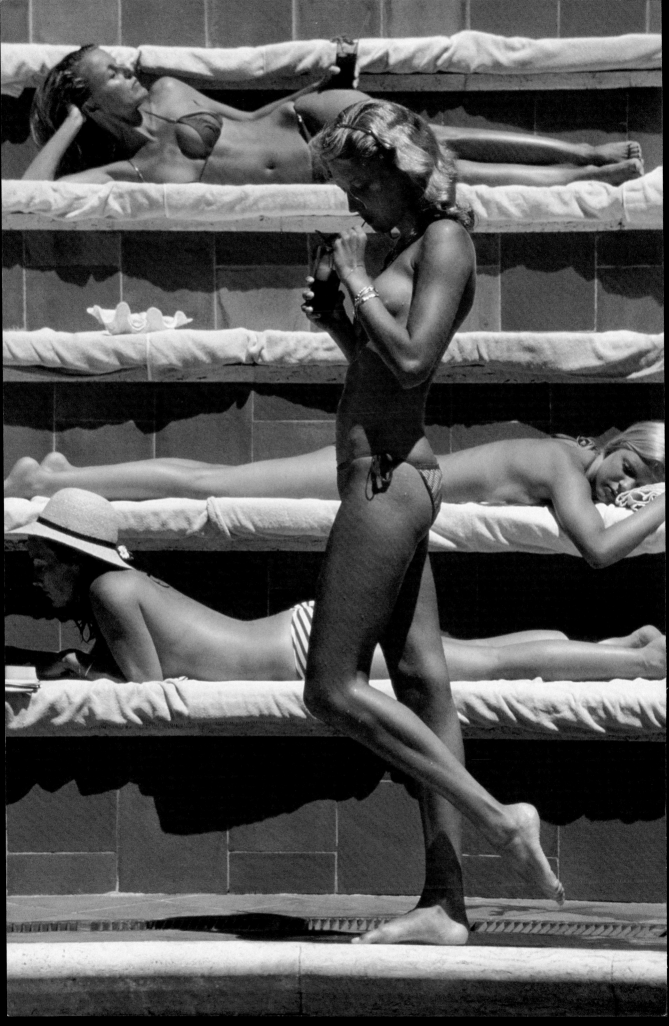

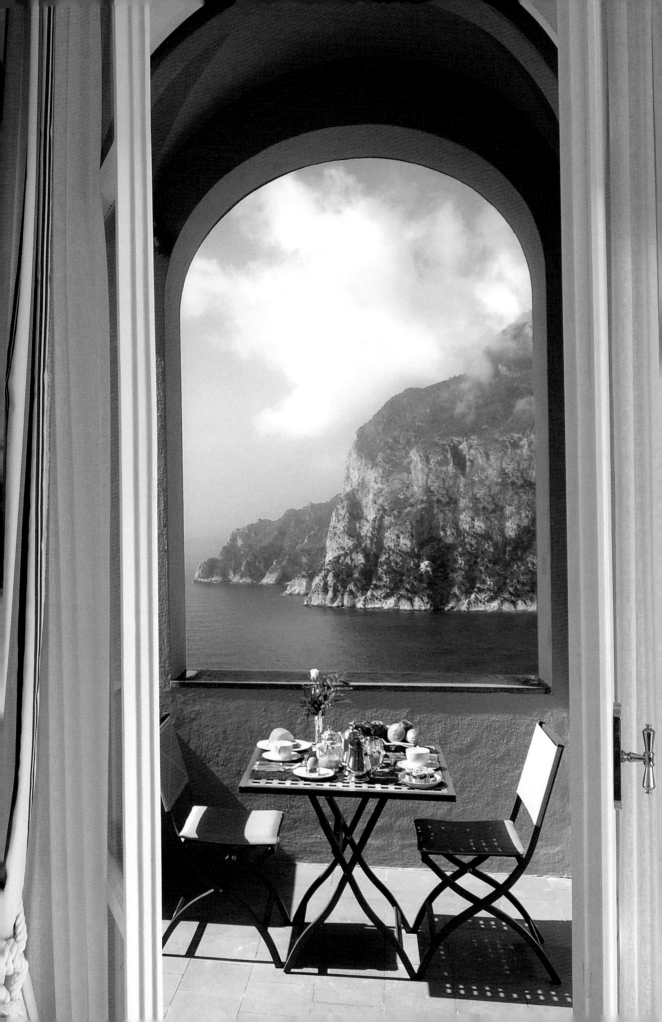

situated in the Marina Grande. The property may well stimulate more commercial development in this part of the island, which is where most tourists arrive and depart, by hydrofoil, ferry, and private craft.

In Anacapri, there is only one truly deluxe hotel, the Capri Palace Hotel & Spa. Owner Tonino Cacace credits its success to its combination of contemporary decor, art-filled public areas, a playfulness (some suites are named after famous people—the Mondrian, the Hepburn, the Maria Callas, the Gwyneth Paltrow), a first-class spa, and a staff that puts its clientele's needs above its own. "When my father died in 1975, I was only twenty-three. In that instant my life changed. I had just graduated from law school and was interested in philosophy and humanities studies. I knew nothing about accounting, nothing about business. But I realized that I had to do something different from what the other hotels were doing."

Today, the Capri Palace Hotel & Spa has become to Anacapri what the Quisisana is to Capri: a grand hotel in every sense of the term and one dedicated to its guests. The hotelier's latest endeavors have been to take over and begin remodeling a popular restaurant called Add'o Riccio (it will be called Il Riccio), above the Blue Grotto; and beyond that, a project that involves exposing the island's children to art, literature, and culture. All this from a man who still insists that "I am merely a child of my village."

Previous Pages: One of the most iconic images of Capri, taken by the pool of the Hotel Punta Tragara by Slim Aarons in 1980; a terrace at the Punta Tragara.

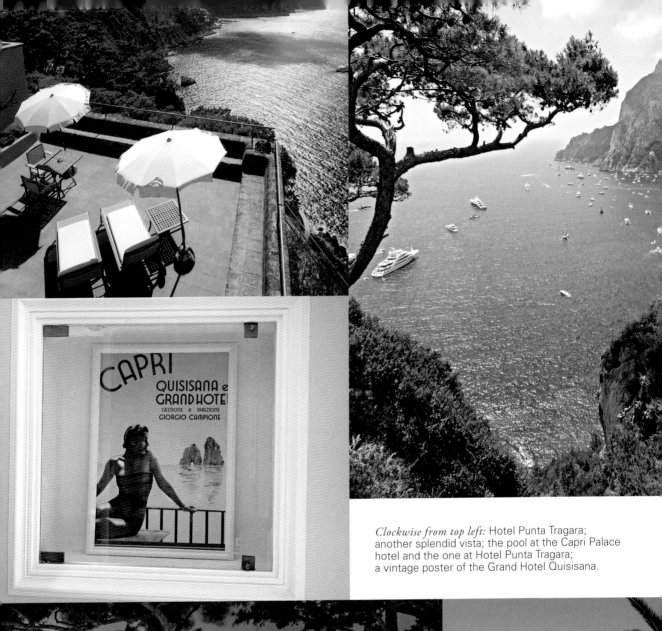

Clockwise from top left: Hotel Punta Tragara;
another splendid vista; the pool at the Capri Palace
hotel and the one at Hotel Punta Tragara;
a vintage poster of the Grand Hotel Quisisana.

*" When I was four years old water-skiing
behind my dad's Riva, I saw for the first time
the mermaid shape of Capri approaching. It was
a surreal moment for a kid my age, to look at this
island so different from the rest in the bay of Naples,
different because of its wild nature, high cliffs,
and seagulls, the scent of pine trees and the beauty
of the most intense blue water I had ever seen. "*

ROBERTO FARAONE MENNELLA

*" I fell in love with Capri instantly.
The flowers, white jasmine, the aromas.
When you are there, you feel totally free.
It's like a big summer camp for adults.
Everybody coexists and it is multigenerational. "*

BARBARA CIRKVA SCHUMACHER

* ❝ Capri was a place for romances. I lived for eleven years with someone I met there. But it was—and is—also a place for friendship. The same crowd, more or less, still comes to the Scalinatella, where I now stay every July. It's like home. The terrace overlooks the sea on one side and the baby mountains on the other.*

What do I do on Capri? Blissfully, nothing. I read in the morning, take long walks in the afternoon, have dinner with friends at night (we like Da Giorgio, right behind the bus stop and overlooking the whole of Naples). It's nothing more complicated than that. I've been spending every summer there since 1961. I'm a world traveler. I went to China the first year it opened up its borders to Americans and went to Angkor Wat early on, before others did. But Capri calls me—and so I go. ❞

RENEE MYERS

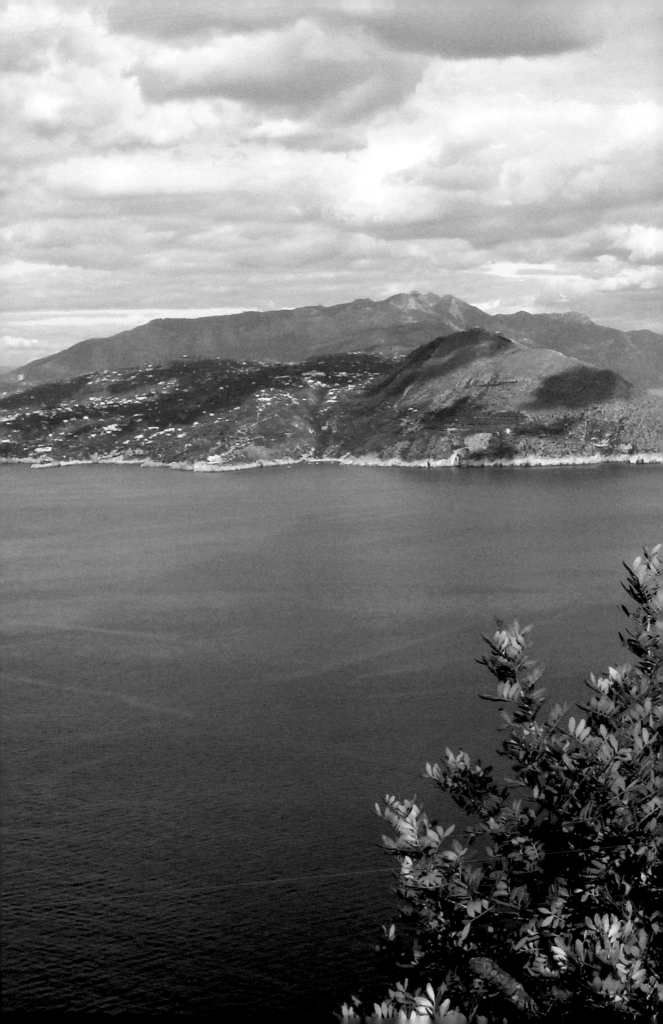

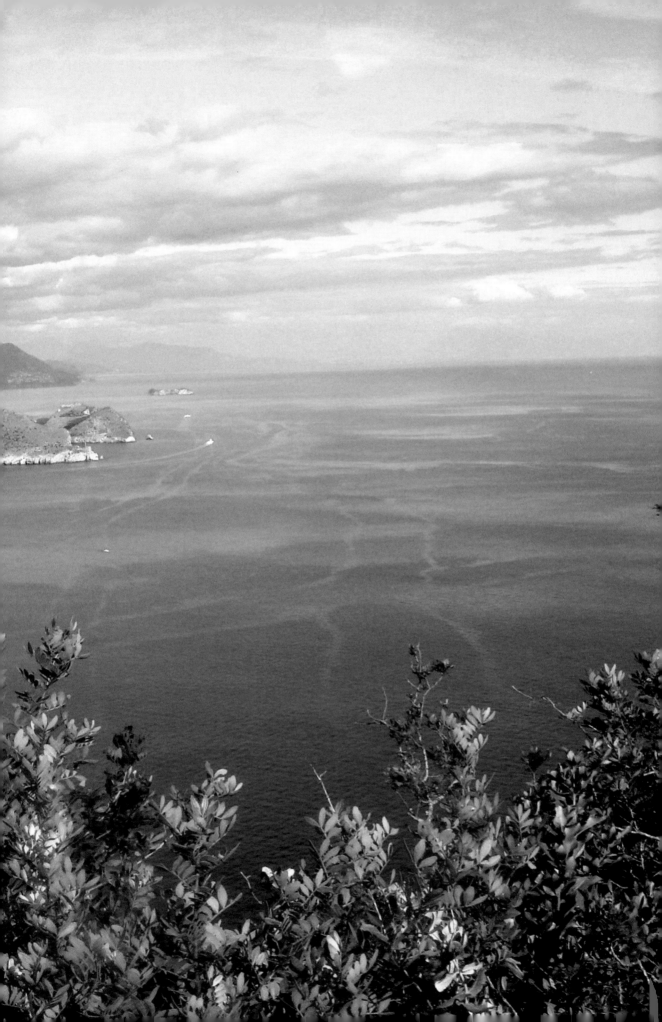

DIRECTORY

HOTELS

Grand Hotel Quisisana
Via Camerelle, 2
Capri Town
Tel: 39 (081) 837 0788
info@quisisana.com
quisisana.com

Hotel La Scalinatella
Via Tragara, 8
Capri Town
Tel: 39 (081) 837 0633
info@scalinatella.com
scalinatella.com

Casa Morgano
Via Tragara, 6
Capri Town
Tel: 39 (081) 837 0158
info@casamorgano.com
casamorgano.com

Capri Palace Hotel & Spa
Via Capodimonte, 14
Anacapri
Tel: 39 (081) 978 0111
info@capripalace.com
www.capripalace.com

Punta Tragara
Via Tragara, 57
Capri Town
Tel: 39 (081) 837 0844
info@hoteltragara.it
www.hoteltragara.com

Luna
Viale Matteotti, 3
Capri Town
Tel: 39 (081) 837 0433
Info@lunahotel.com
www.lunahotel.com

Hotel La Palma
Via Vittorio Emanuele, 39
Capri Town
Tel: 39 (081) 837 0133
info@lapalma-capri.com
www.lapalma-capri.com

Gatto Bianco
Via Vittorio Emanuele, 32
Capri Town
Tel: 39 (081) 837 0446
h.gattobianco@capri.it
www.gattobianco-capri.com

JK Place Capri
Via Prov. Marina Grande, 225
Capri Town
39 (081) 838 4001
info@jkcapri.com
www.jkcapri.com

Caesar Augustus Hotel
Via G. Orlandi, 4
Anacapri
www.caesar-augustus.com

RESTAURANTS

Il Riccio
Via Gradola, 4/6
Localitá Grotta Azzurra
Anacapri
www.ristoranteilriccio.com
Tel: 39 (081) 837 1380

Aurora
Via Fuorlovado, 18/22
Capri Town
39 (081) 837 0181
www.auroracapri.com

La Capannina
Via Le Botteghe, 12/14
Capri Town
Tel: 39 (081) 837 0732
www.capannina-capri.com

Edodé
Via Camerelle, 81/83
Capri Town
Tel: 39 (081) 838 8252
edode@russocapri.com
www.edodécapri.com

Lido del Faro
Punta Carena
Anacapri
Tel: 39 (081) 837 1798
info@lidofaro.com
www.lidofaro.com

La Fontelina
Localitá Faraglioni
Capri Town
Tel: 39 (081) 837 0845
fontelina@capri.it

Da Giorgio
Via Roma, 34
Capri Town
Tel: 39 (081) 837 5777
info@dagiorgiocapri.com
www.dagiorgiocapri.com

Le Grottelle
Via Arco Naturale
Capri Town
Tel: 39 (081) 837 5719
grotellecapri@aruba.it

Da Luigi ai Faraglioni
Via Faragolioni 5
Capri Town
Tel: 39 (081) 837 0591
deluigi@hotelcertosella.com
www.hotelcertosella.com

Previous Pages: A view of the Amalfi Coast from Capri. *Following Pages*: Marina Grande, 2008.

Da Paolino
Via Palazzo a Mare, 11
Capri Town
Tel: 39 (081)-837-61-02
paolino@capri.it

Lo Scoglio
Marina del Cantone
Massa Lubrense
Nerano, Positano
Tel: 39 (081) 808 1026

Villa Verde
Vico Sella Orta, 6
Capri Town
Tel: 39 (081) 837 7024
info@villaverde-capri.com
www.villaverde-capri.com

L'Olivo
Capri Palace Hotel & Spa
Via Capodimonte, 14
Anacapri
Tel: 39 (081) 978 0111
www.capripalace.com

SHOPPING

Alberto e Lina
Campanina
Via Vittorio Emanuele, 18
Capri Town
Tel: 39 (081)-837-06-43
albertoelina@libero.it

Chantecler
Via Vittorio Emanuele 51
Capri Town
Tel: 39 (081) 837 0544
Capri@chantecler.it
www.chantecler.it

DL Capri
Via Vittorio Emanuele 47
Capri Town
Tel: 39 (081) 837 7845
www.liguoricapri.com

Grazia Vozza
Via Fuorlovado, 38
Capri Town
Tel: 39 (081) 837 4010
gravoz@libero.it
www.graziavozza.com

100% Capri
info@100x100capri.it
www.100x100capri.it

Flair
Via Roma, 73/a
Capri Town
Tel: 39 (081) 837 4854
capri@flair.it
www.flair.it

La Parisienne Boutique
Piazza Umberto 1, 7
Capri Town
Tel: 39 (081) 837 0283
laparisienne@libero.it
www.laparisiennecapri.it

Raku Capri
Via Le Botteghe, 46
Capri Town
Campania/Isole Partenopee/
Isola Capri
Tel: 39 (081) 837 0165
www.rakucapri.it

Russo Uomo
Piazzetta Quisisana
Capri Town
Tel: 39 (081)-8388200

Carthusia
There are several shops but the
factory's address is:
Vialle Matteotti, 2d
Tel: 39 (081) 837 0368
Capri Town
www.carthusia.com

Canfora
Via Camerelle, 3
Capri Town
Tel: 39 (081) 837 0487
www.canfora.com

Giuseppe Faiella
Via Le Botteghe, 21
Capri Town

La Conchiglia
Via Camerelle, 18
Capri Town
Tel: 39 (081) 837 8199
www.laconchigliacapri.com

Faraone Mennella
Via Fuorlovado 23
Capri Town
www.faraonemennella.com

NIGHTLIFE

Anema e Core
Via Sella Orta, 39/e
Capri Town
Tel: 39 (081) 837 6461
www.anemaecore.com

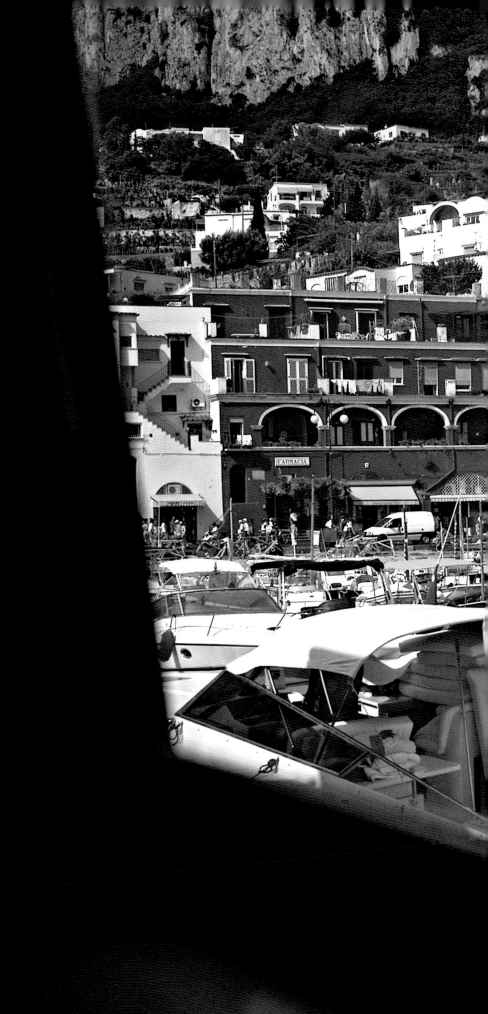

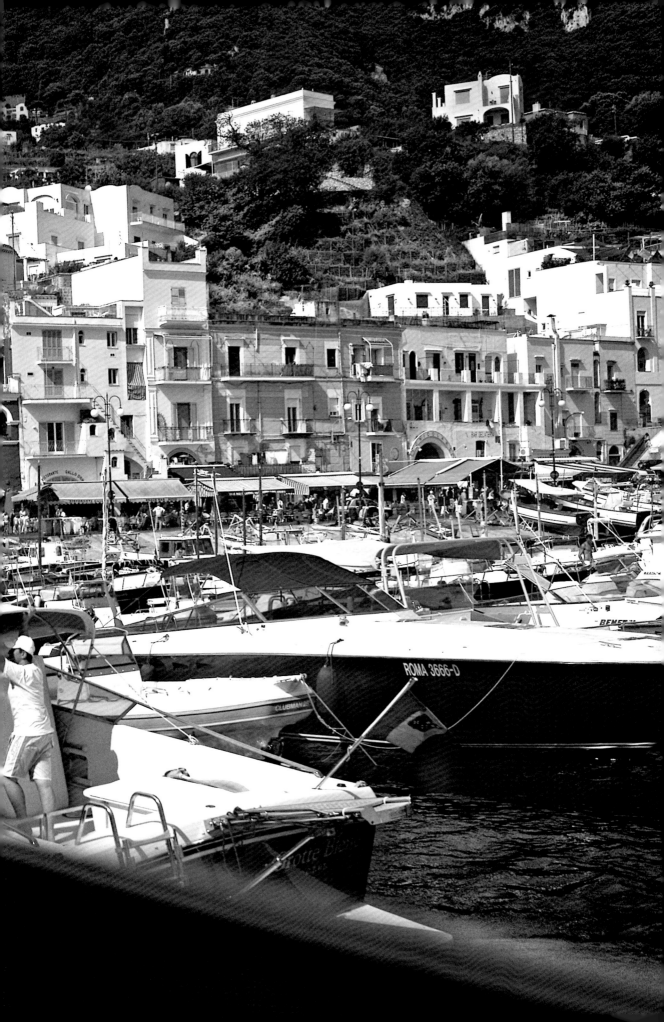

ACKNOWLEDGMENTS

I would like to thank the following individuals, who were invaluable in the creation of *In the Spirit of Capri* and who, in so many ways, epitomize the island's exuberance: Tonino Cacace; Ermanno Zanini; Nicolino and Carmen Morgano; Gianfranco Morgano; Michael and Kim McCarty; Amedeo Scognamiglio; Roberto Faraone Mennella; Colin Cowie; Cyril Dwek; Natasha di Santis; Costanzo Paturzo; Marisa May; Tony May; Diego Della Valle; Marisa Berenson; Valentino Garavani; Giancarlo Giammetti; Bruce Hoeksema; Ellen Niven; Oscar de la Renta; Massimo Ferragamo; Pilar Crespi; Diane von Furstenberg; Michael Kors; Billy Daley; Dorothea Liguori; Amerigo Liguori; Denise Rich; Grazia Vozza; Peter Cottino, Gianluca Isaia, Adriana Di Fiore; Francesca Di Fiore; Marioli Federico; Cathryn Collins and Dr. Gerald Imber; Richard David Story; Barbara Cirkva and John Schumacher; Adrienne Vittadini; Robert Rufino; Renee Myers; Sherri Donghia; James Brodsky; and Helena and Roman Martinez; and Elaine Fabrikant. And, finally, the people who are always by my side and in my corner: Cathie Black; Michael Clinton; Debra Shriver; John Cantrell; Mary Shanahan; Glenna MacGrotty; and, above all, my husband, Colt Givner.

The publishers would like to thank Piero and Ségolène, who are at the origins of their love for Capri; Cristiano, for an unforgettable Mediterranean afternoon drive on his lovely boat; Eva and Lorenzo, for their joyful spirit and philosophy of life, and for their useful addresses, such as the one for the great Anema e Core; Marisa, who always lends beauty to our pages; and Pamela, the tasteful author of this book, whose husband, Colt, shared his love for Capri with beautiful photographs.

Photo Acknowledgments: Tiina Björkbacka (The Bernadotte Library); Bengt Böckman; Martha Botts (Oscar de la Renta); Umberto D'Aniello; Silvana Davanzo (Eyedea); Maggie Downing and Silka Quintero (The Granger Collection); Paola Federico (Hotel Punta Tragara); Giuseppe Ferraro (Albergo Gatto Bianco); Gianna Ferri (Carla Mugnaini PR & Advertising-JK Place Hotel); Dilcia Johnson (Corbis); Joo Lee (Leemage); Marisa May; Daniela Mericio (Publifoto-Olycom); Luciana Morresi (Villa San Michele); Lori Reese (Redux); Mallory Samson; Michael Schulman (Magnum Photos); and Barbara von Schreiber.

CREDITS

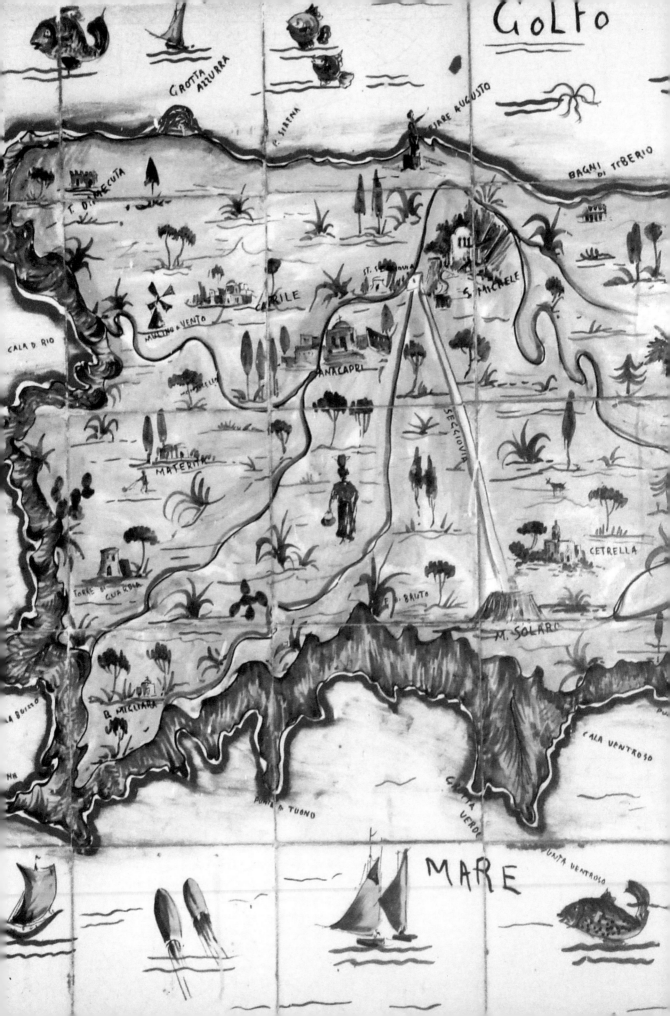